喬漢娜·貝斯福 著

Johanna Basford

迷 幻 海 洋

LOST OCEAN

An Inky Adventure
& Coloring Book

遠流出版公司

迷幻海洋
Lost Ocean: An Inky Adventure & Coloring Book

作者　喬漢娜·貝斯福（Johanna Basford）

譯者　吳琪仁

總編輯　汪若蘭

版面構成　張凱揚

封面設計　張凱揚

行銷企畫　高芸珮

發行人　王榮文

出版發行　遠流出版事業股份有限公司

地址　臺北市南昌路2段81號6樓

客服電話　02-2392-6899

傳真　02-2392-6658

郵撥　0189456-1

著作權顧問　蕭雄淋律師

2015年11月1日　初版一刷

定價　新台幣280元（如有缺頁或破損，請寄回更換）

有著作權·侵害必究

ISBN　978-957-32-7727-9

遠流博識網　http://www.ylib.com　E-mail: ylib@ylib.com

國家圖書館出版品預行編目(CIP)資料

迷幻海洋 / 喬漢娜.貝斯福(Johanna Basford)著 ； 吳琪仁譯. — 初版. — 臺北市 ：遠流, 2015.11
面 ： 公分
譯自 ：Lost ocean : an inky adventure & coloring book
ISBN 978-957-32-7727-9(平裝)

1.繪畫 2.畫冊

947.5　104019002

這本書是屬於
This book belongs to

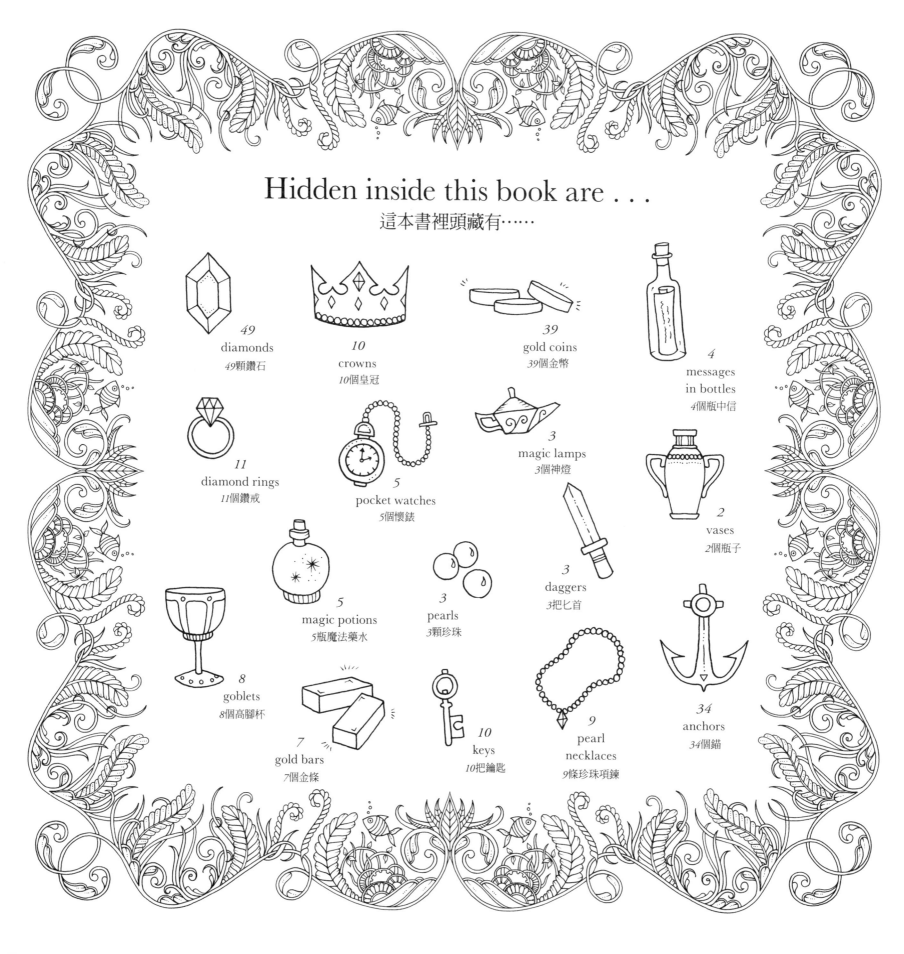

Hidden inside this book are . . .

這本書裡頭藏有……

49
diamonds
49顆鑽石

10
crowns
10個皇冠

39
gold coins
39個金幣

4
messages
in bottles
4個瓶中信

11
diamond rings
11個鑽戒

5
pocket watches
5個懷錶

3
magic lamps
3個神燈

2
vases
2個瓶子

5
magic potions
5瓶魔法藥水

3
pearls
3顆珍珠

3
daggers
3把匕首

8
goblets
8個高腳杯

7
gold bars
7個金條

10
keys
10把鑰匙

9
pearl
necklaces
9條珍珠項鍊

34
anchors
34個錨

前言

《迷幻海洋》是關於一趟奇妙的海底探險旅程，
每一頁都是迷人的插畫，
邀請你塗上色彩，加上小細節。
不論是纏繞的美麗海草，
還是珊瑚礁花園與沈船的遺跡，
這裡有好多好多有趣的東西等著你來探尋！
在本書中，
你會看見樣貌奇特的章魚、奇妙的美人魚、許多色彩斑斕的魚群，
全都等著你用各種顏色，
讓牠們充滿生氣！

當然囉，探險一定要有寶藏才行。
本書每一頁都藏有海盜藏寶箱裡的寶物與首飾。
你可以找出藏在本書各頁裡的所有寶物嗎？

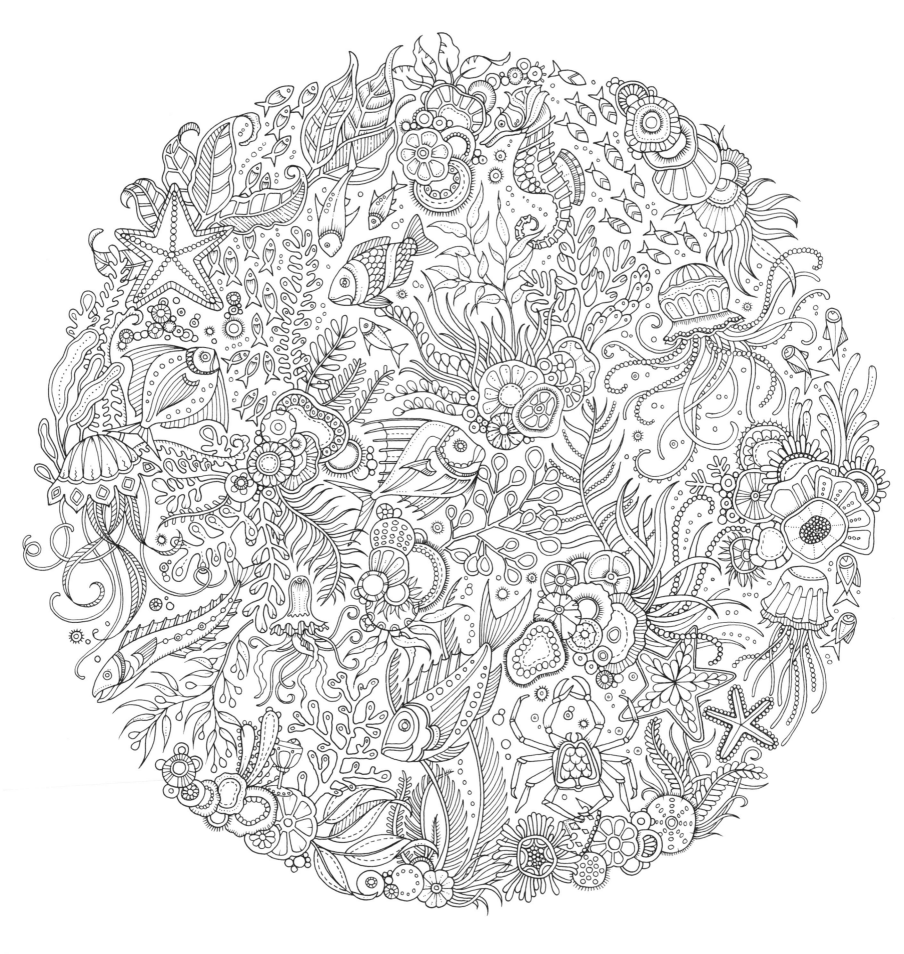

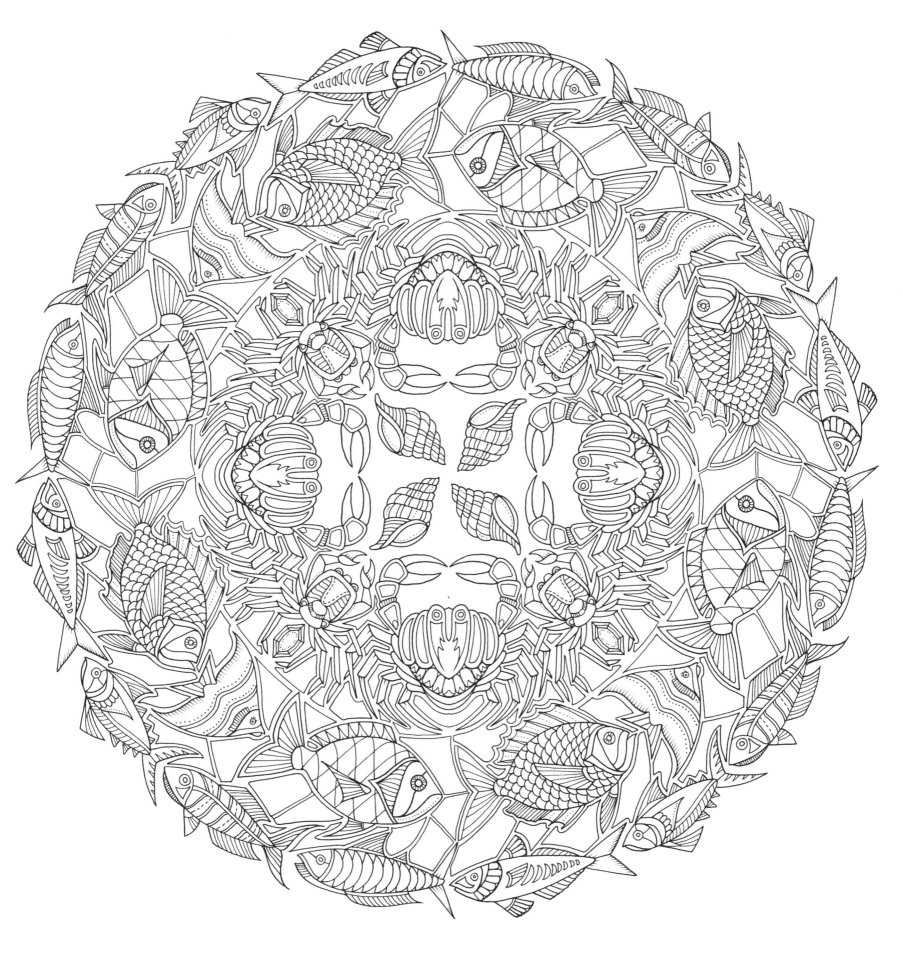

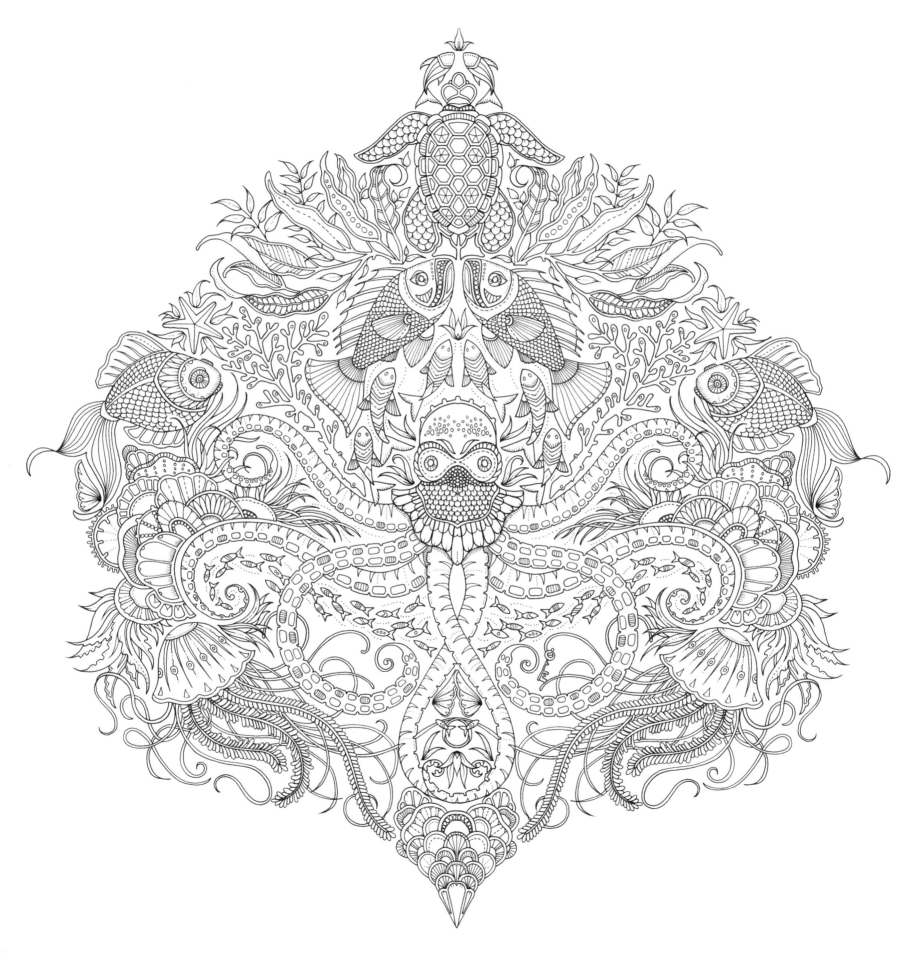

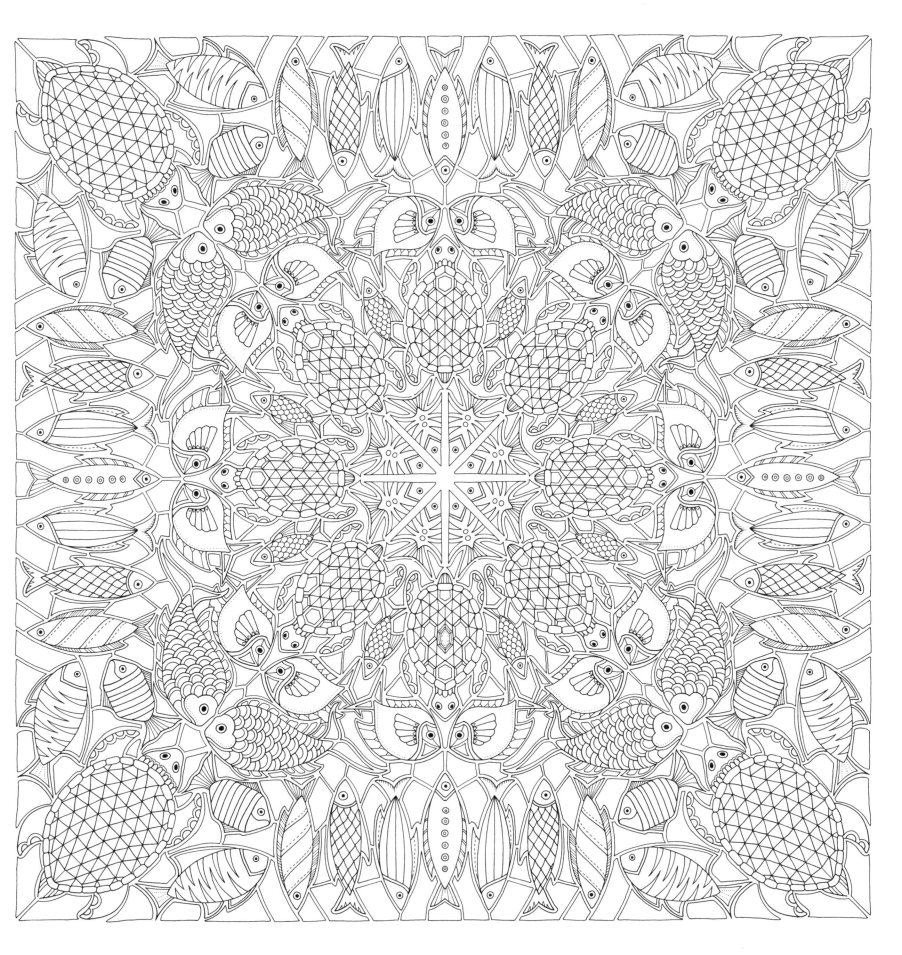

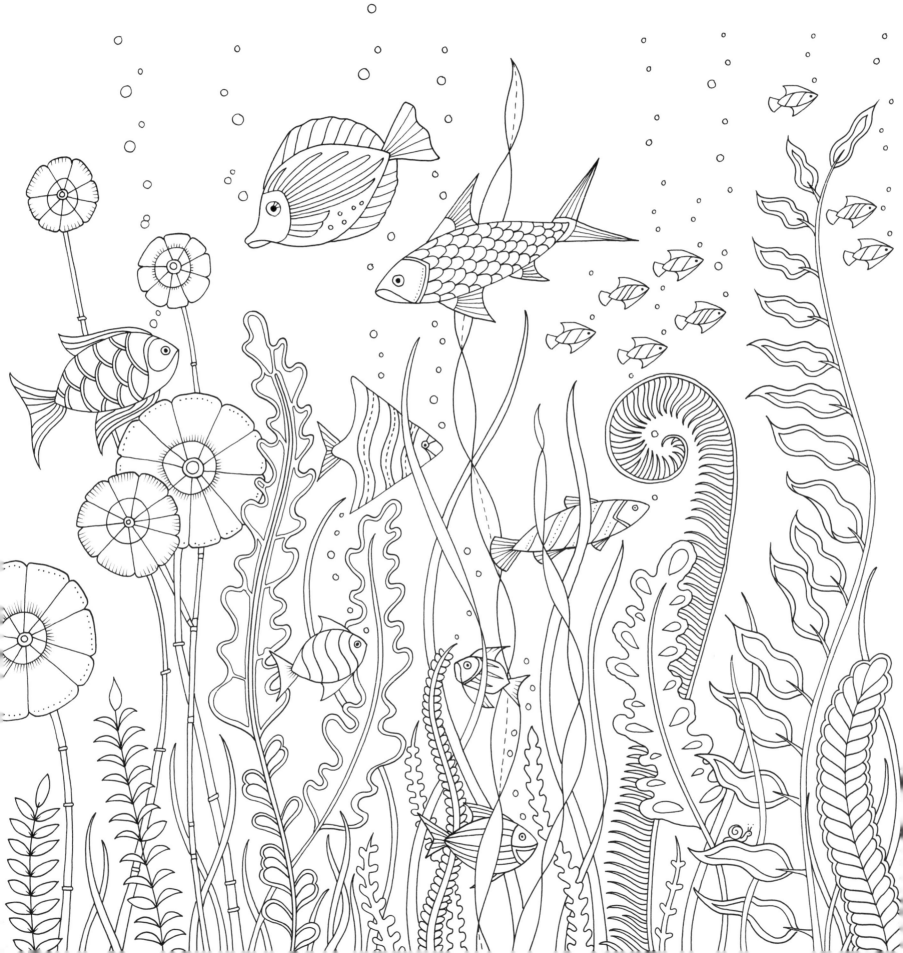

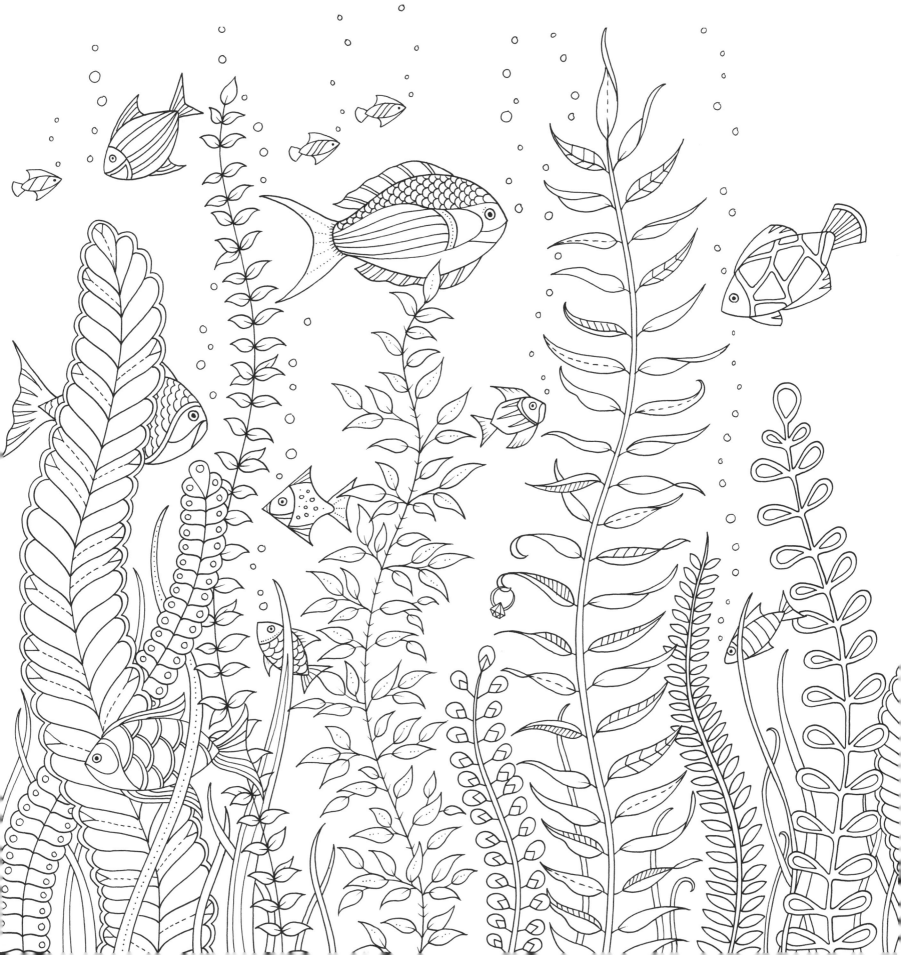

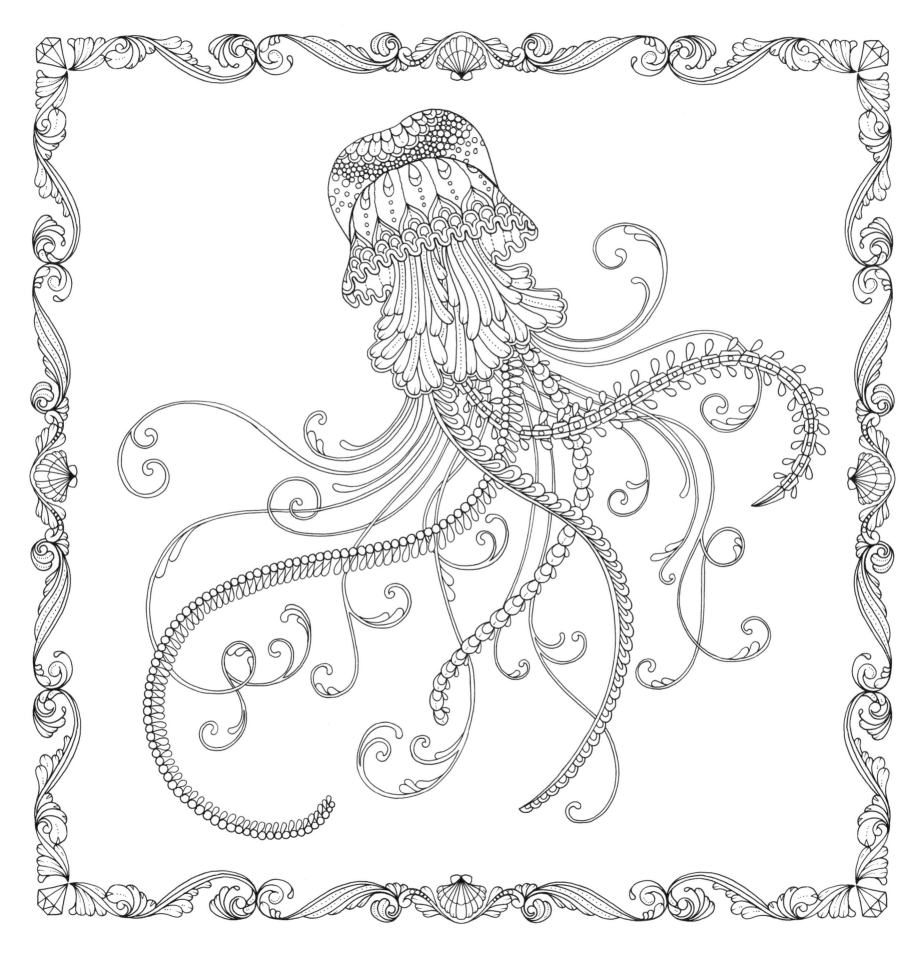

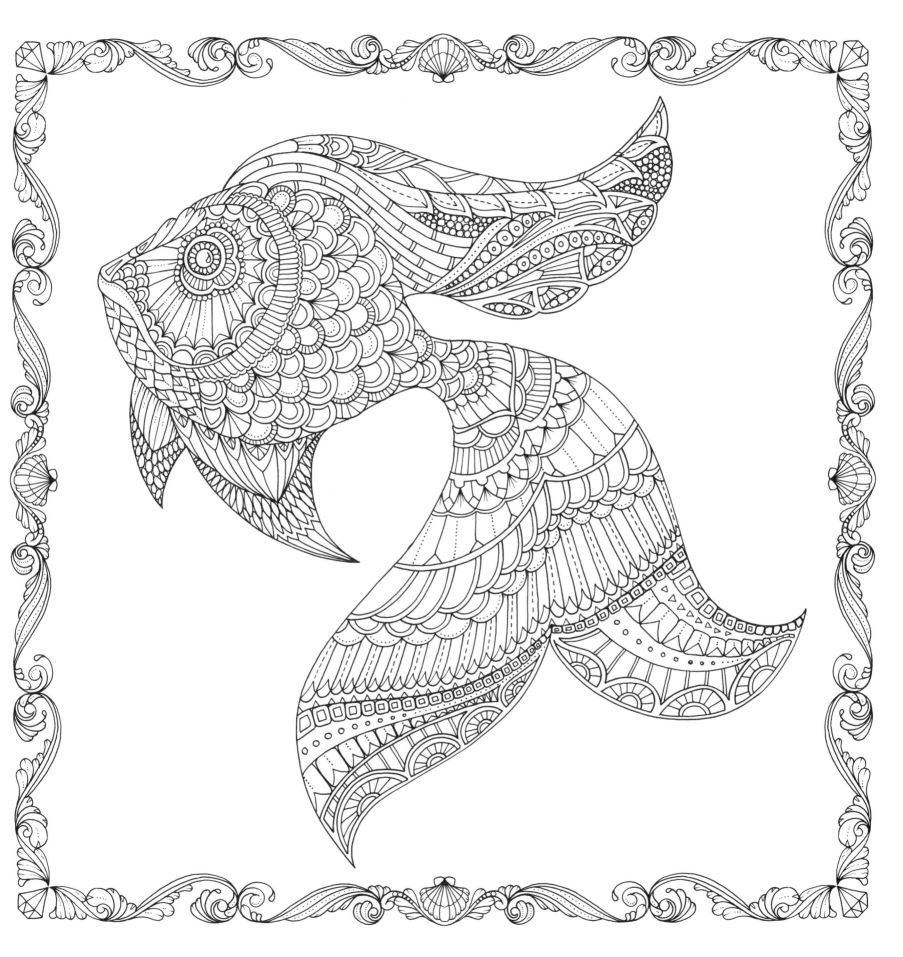

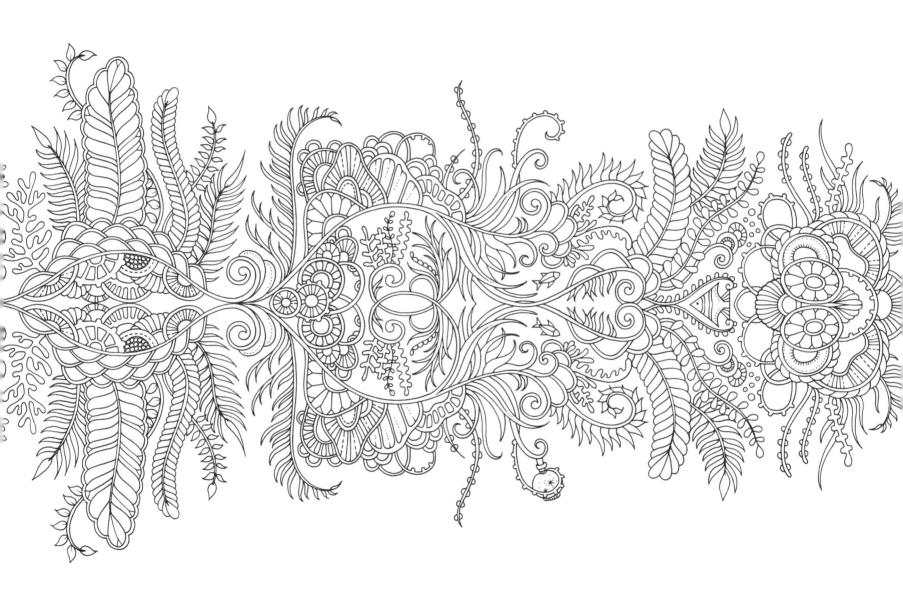

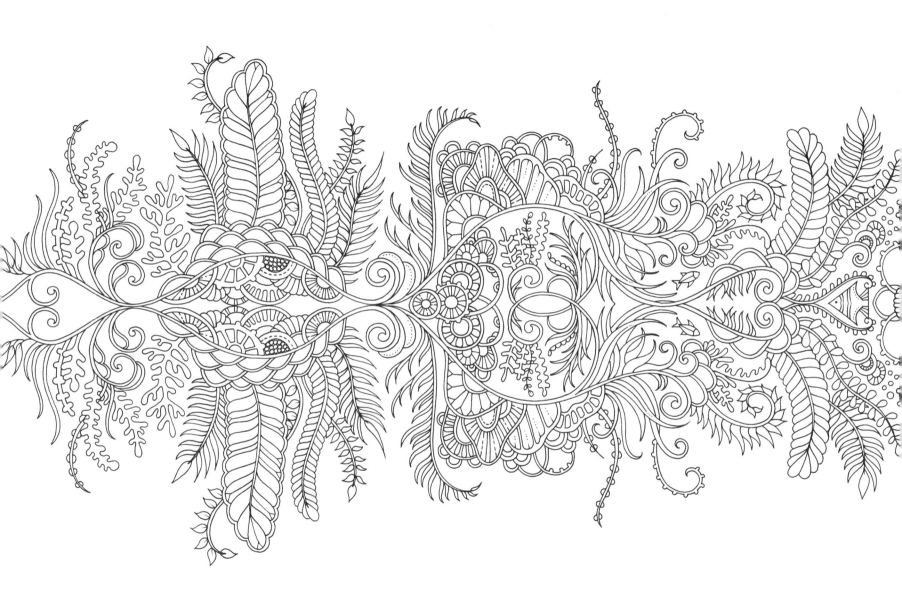

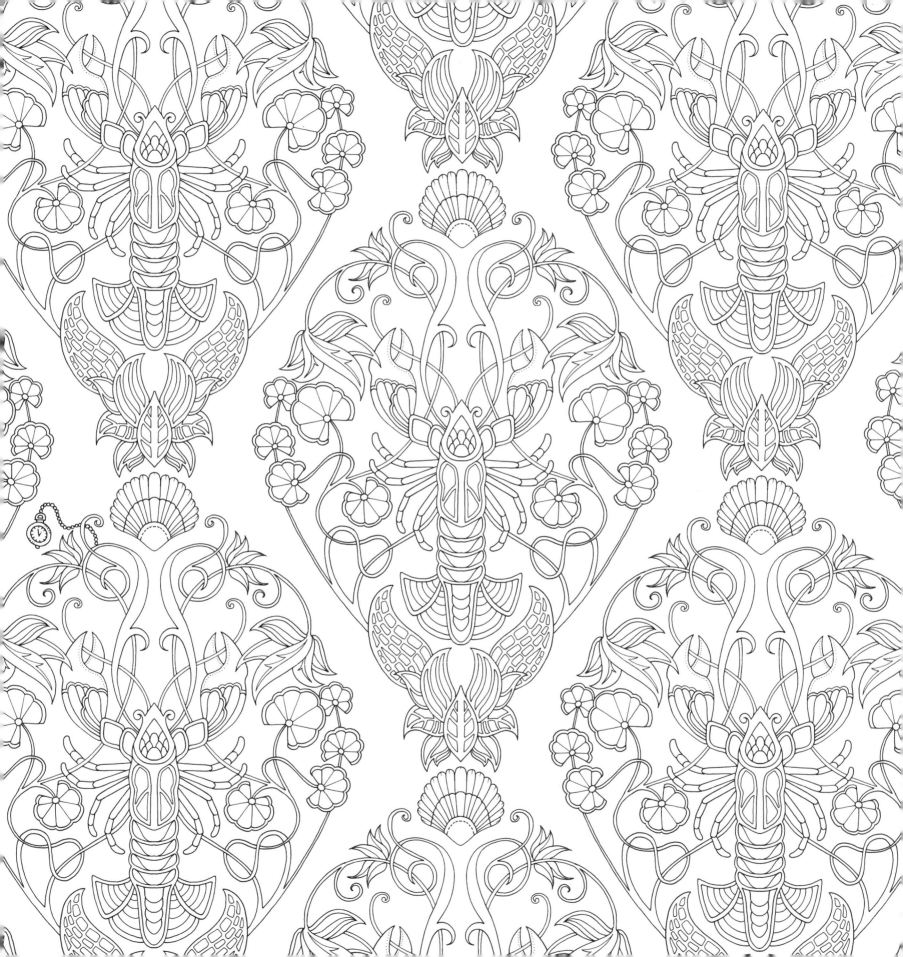

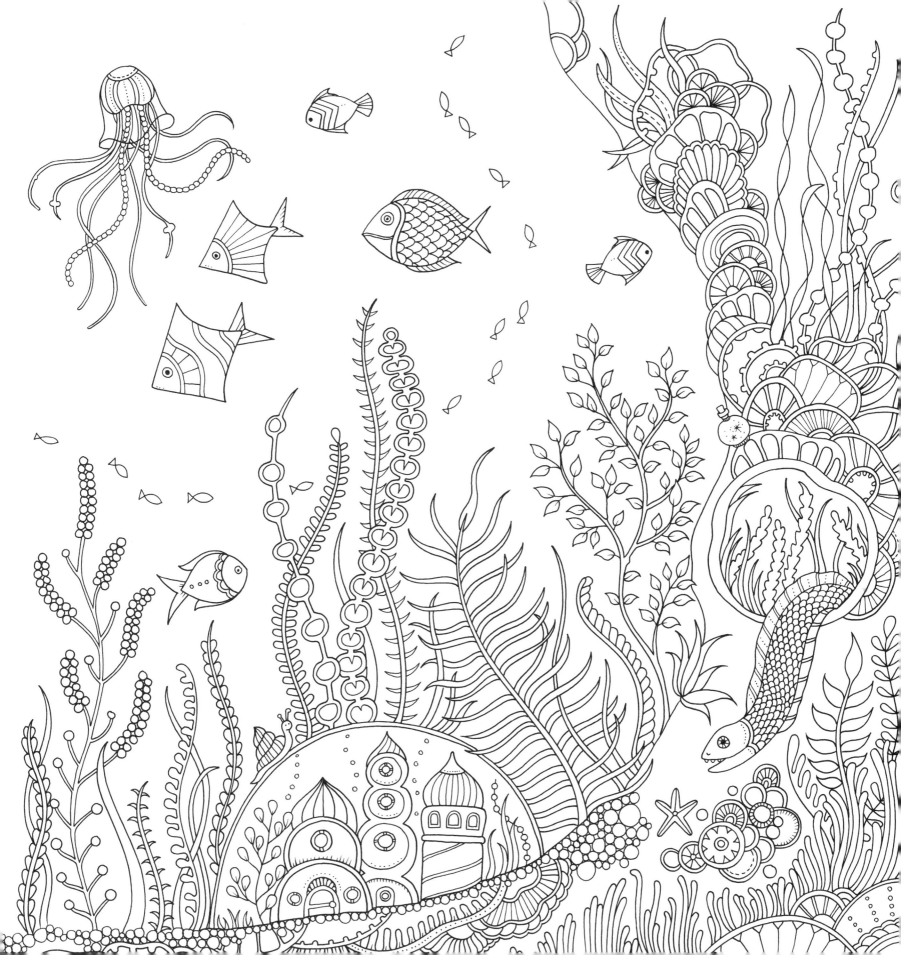

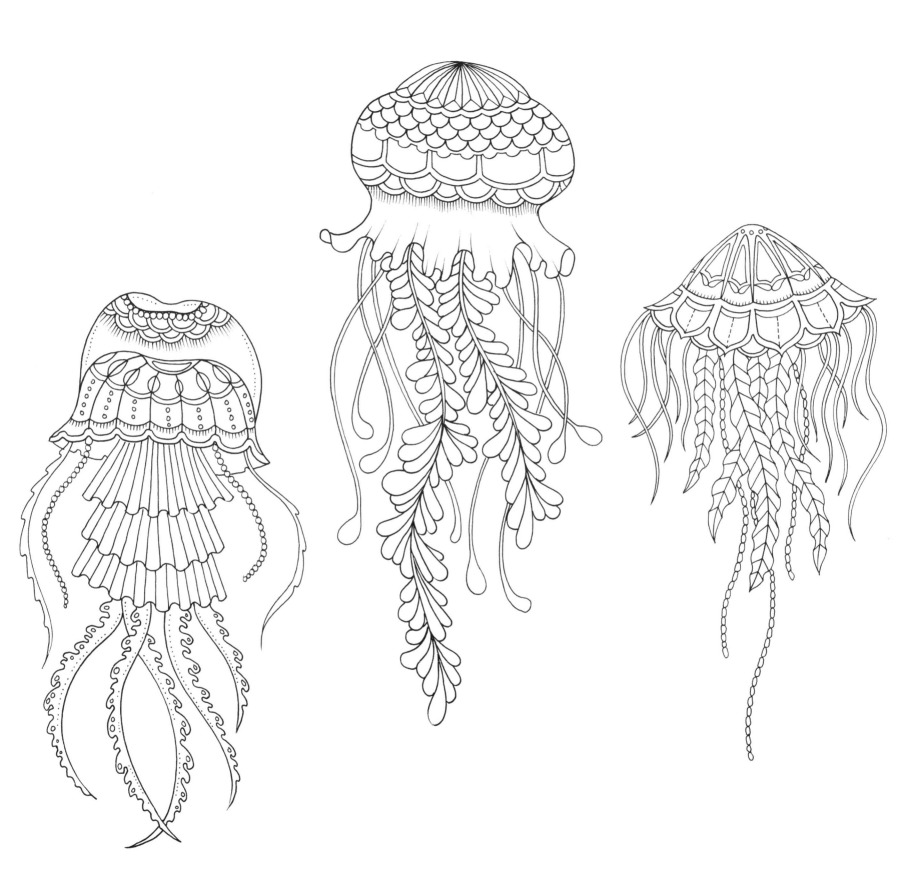

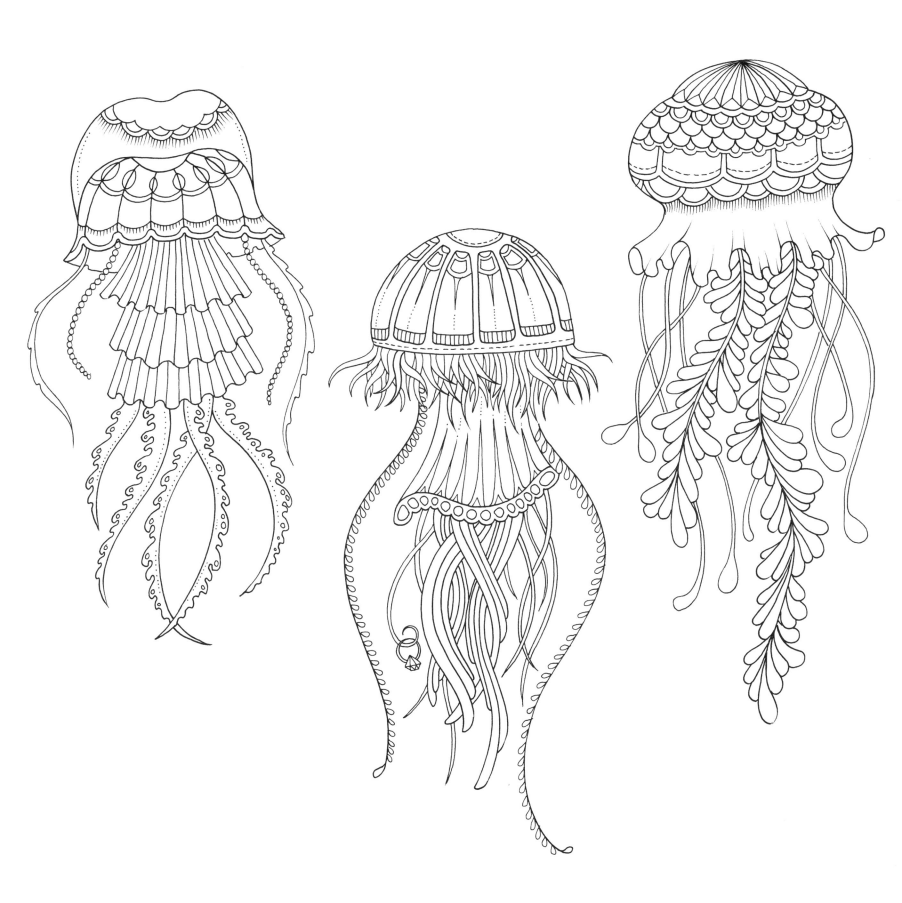

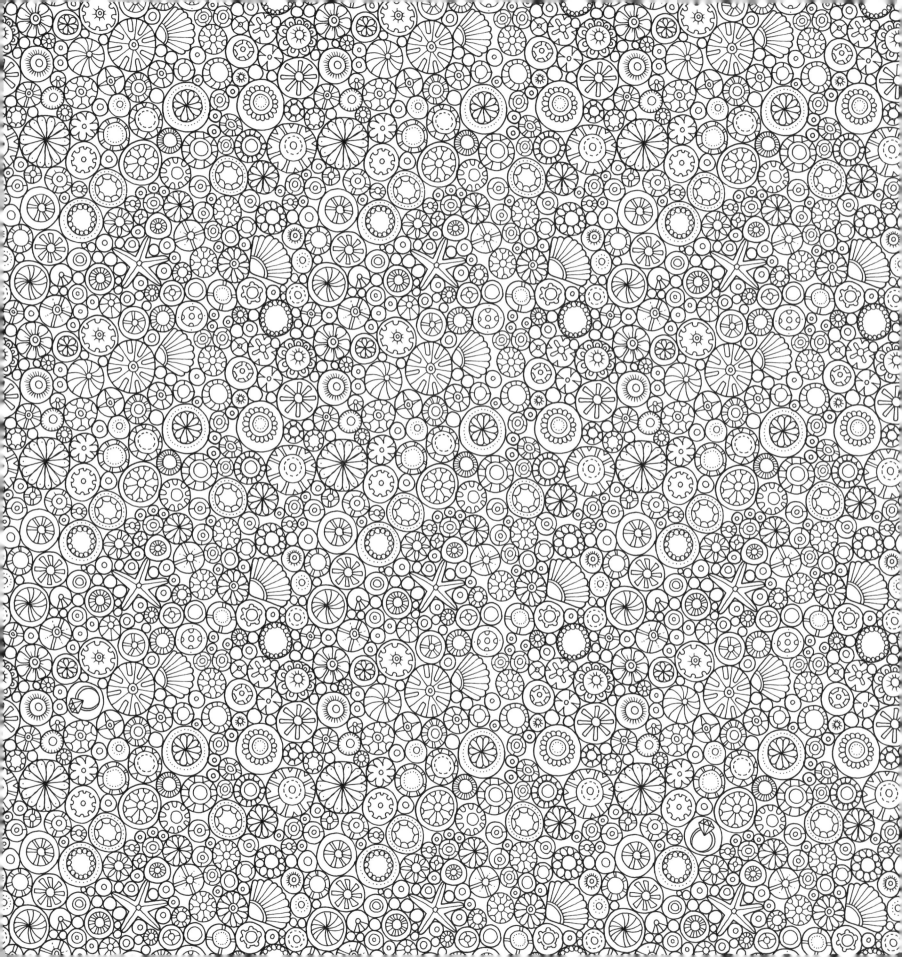

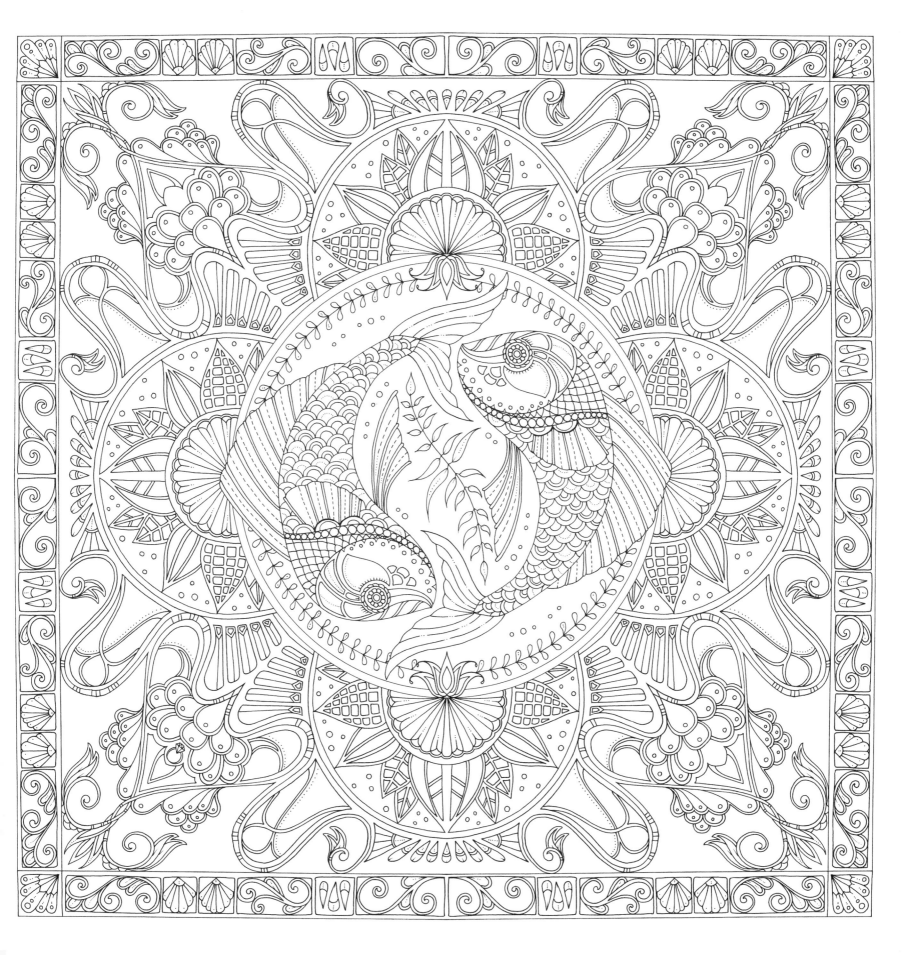

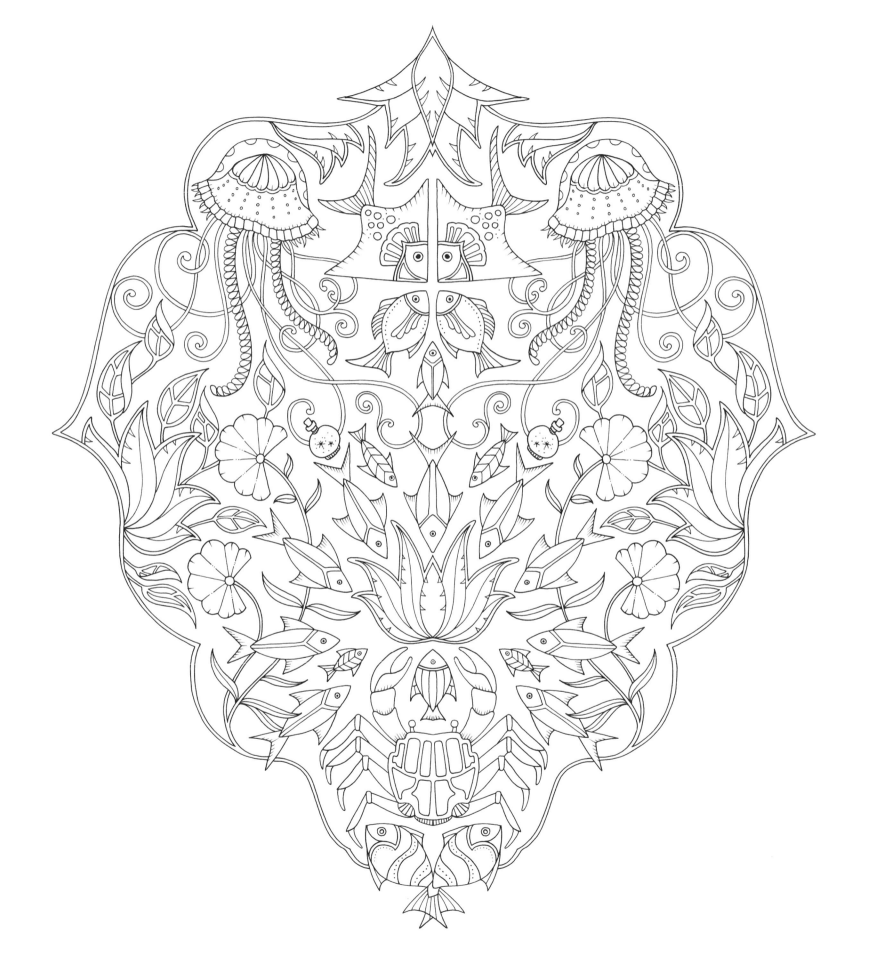

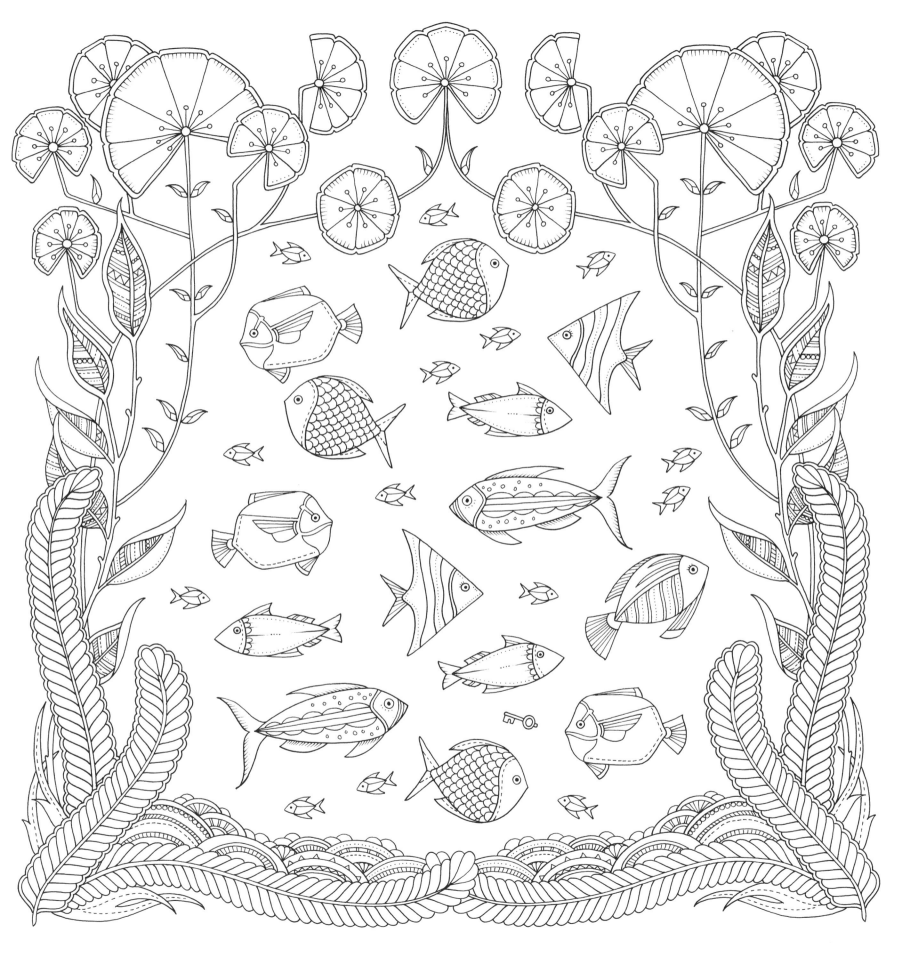

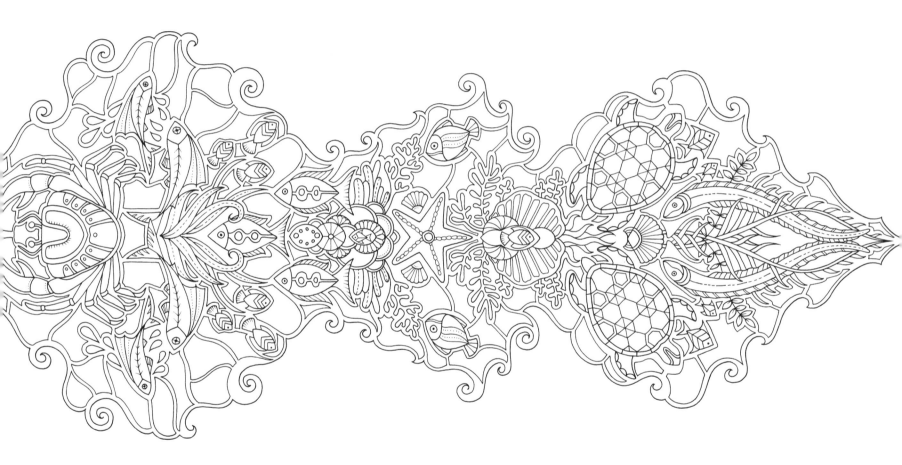

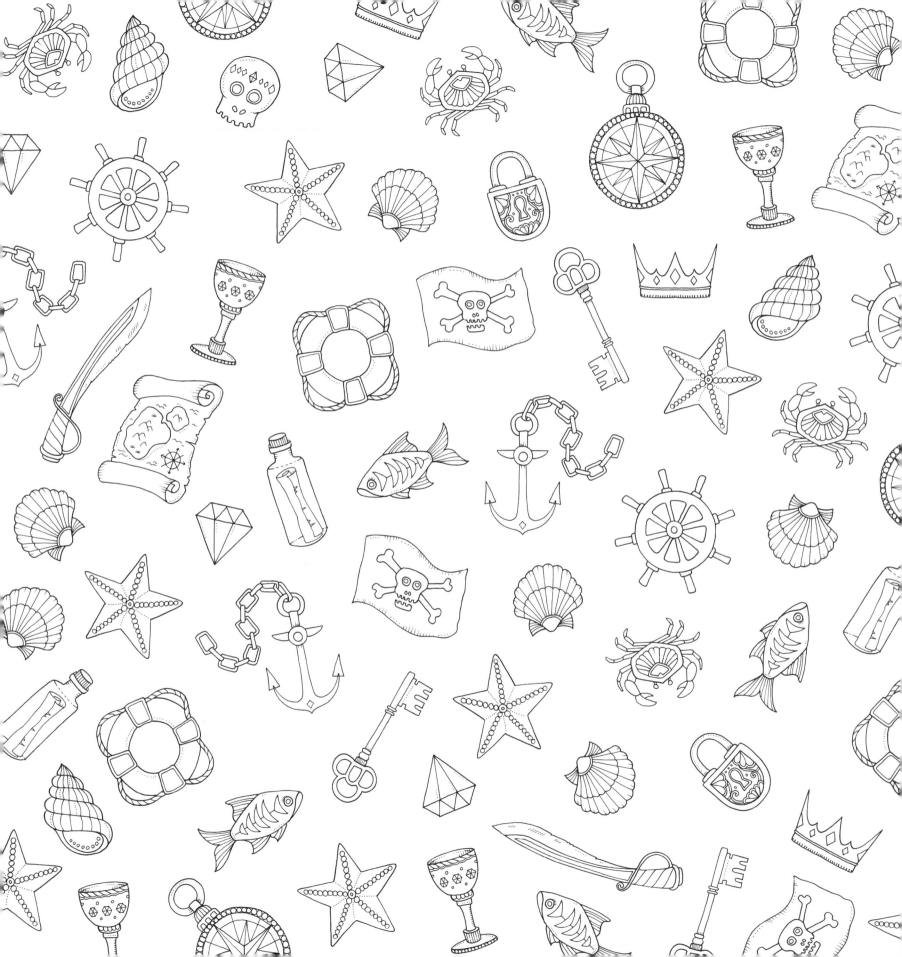

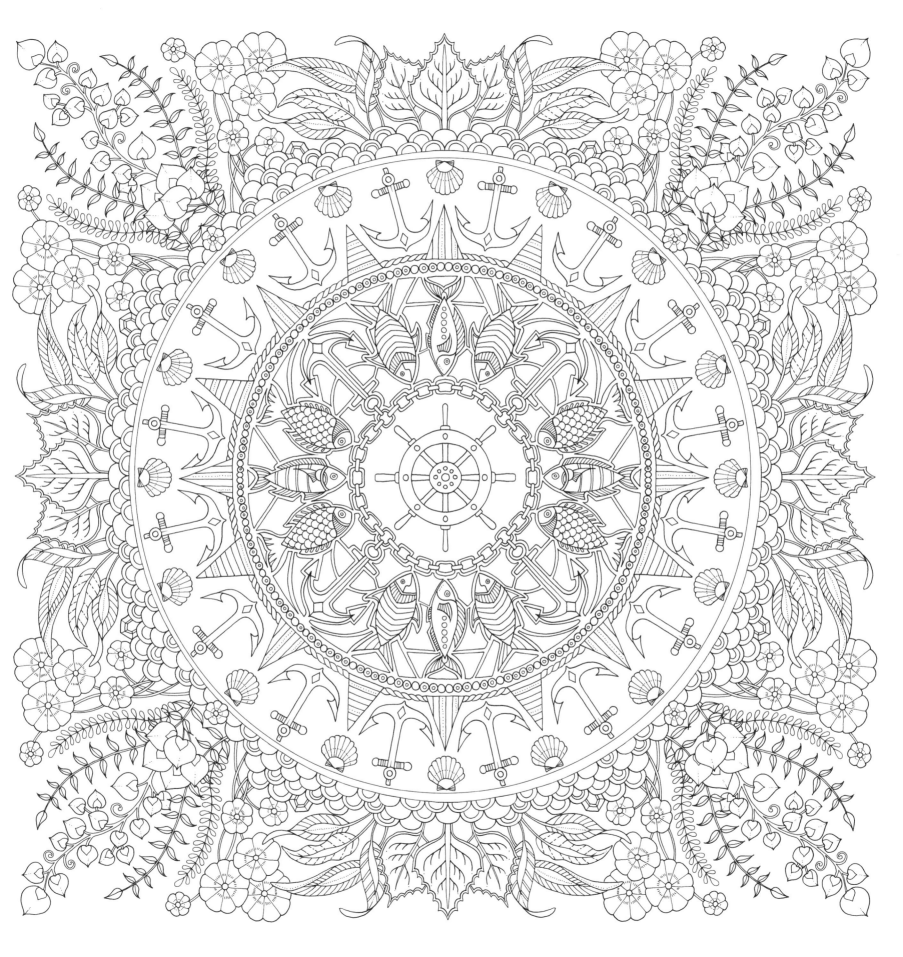

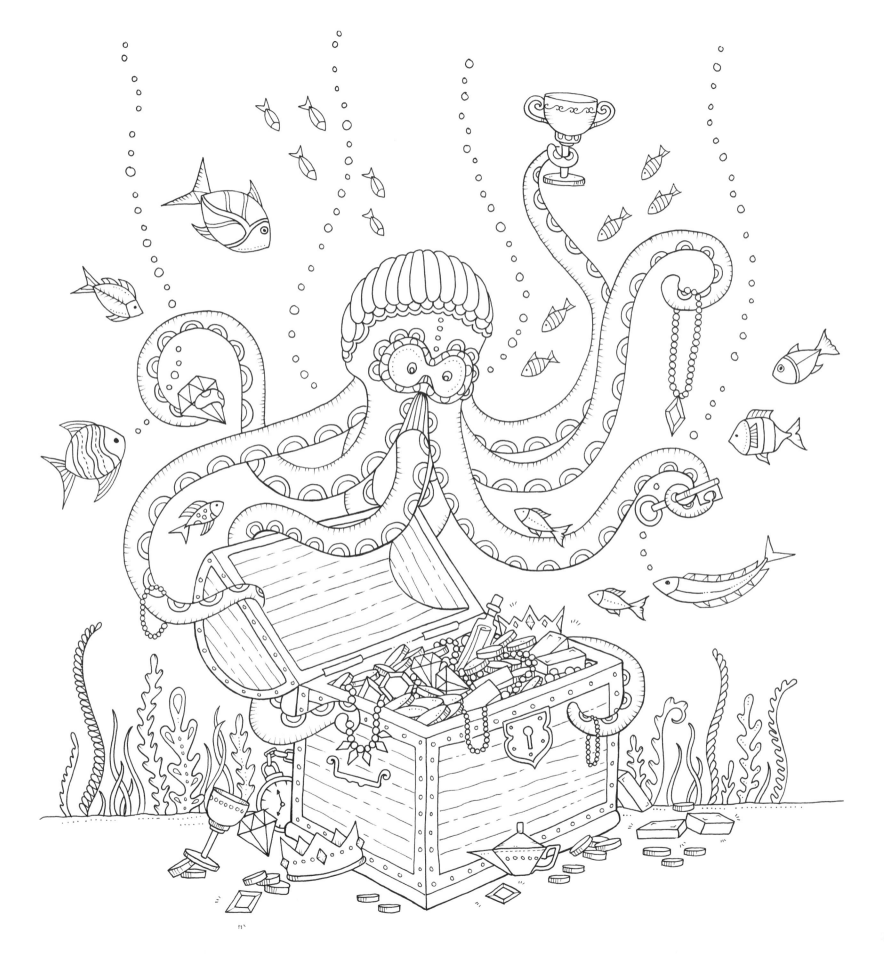

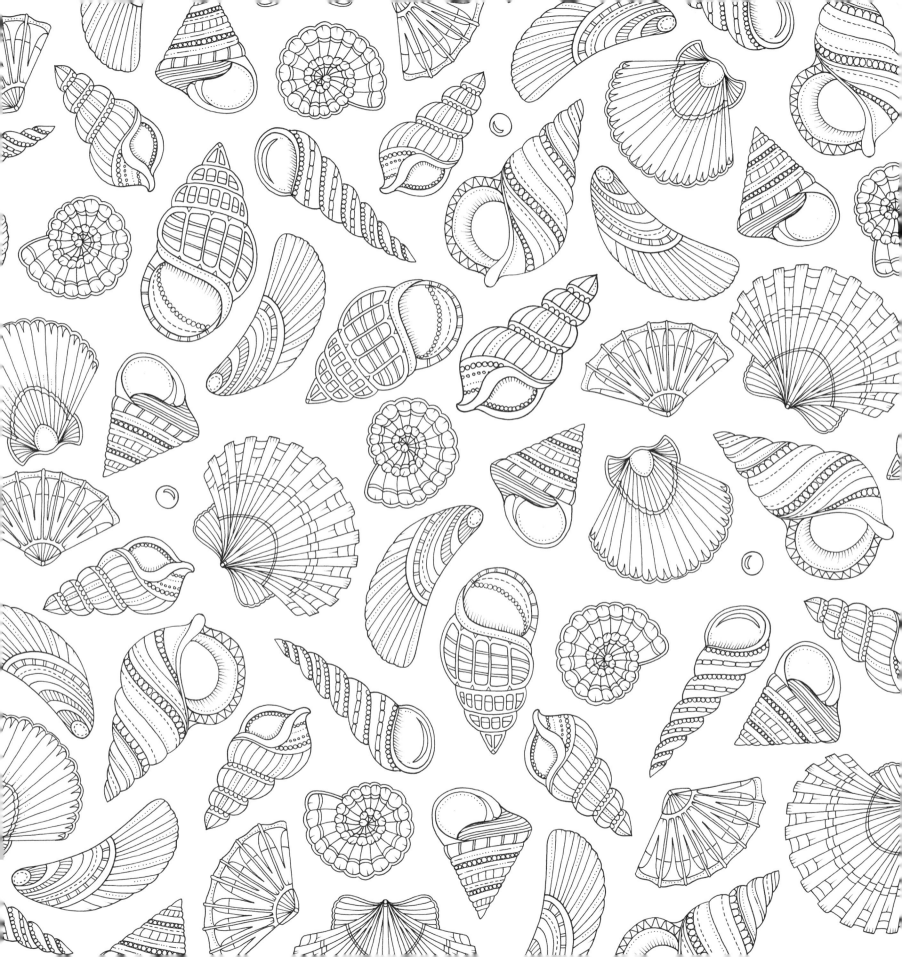

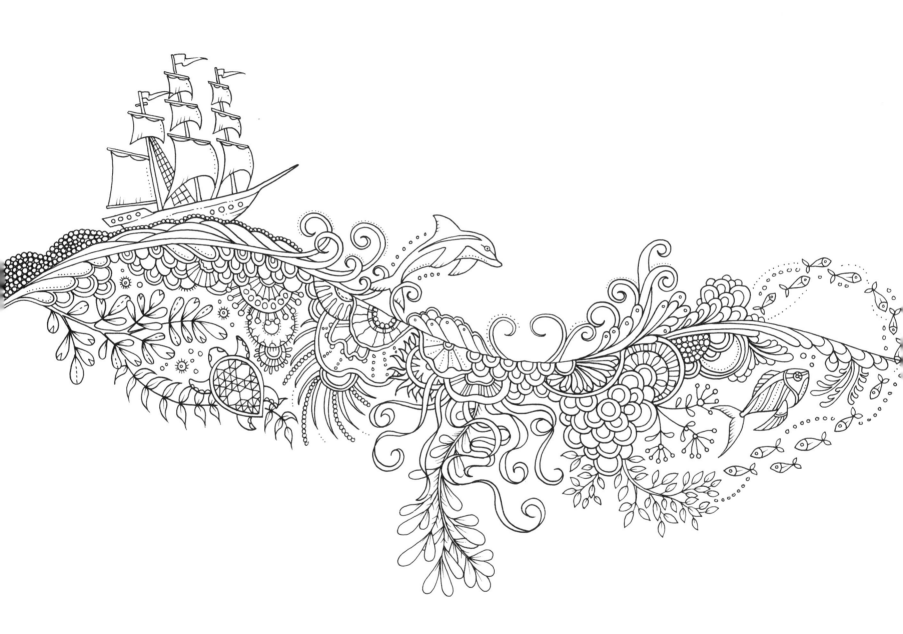

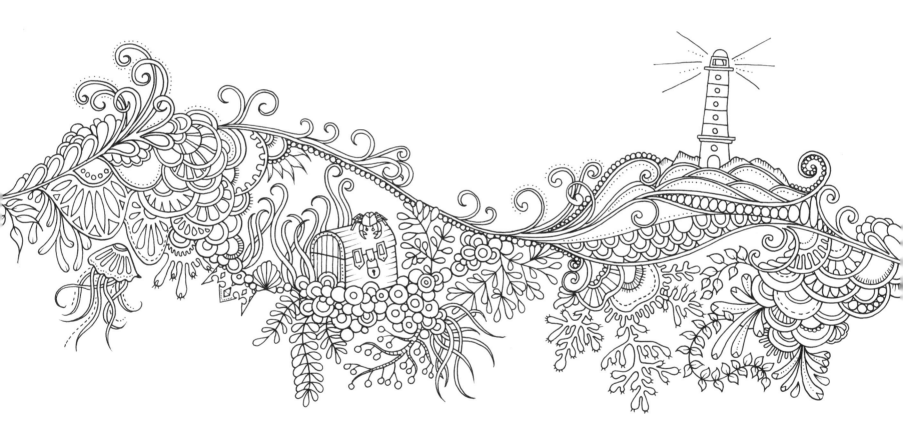

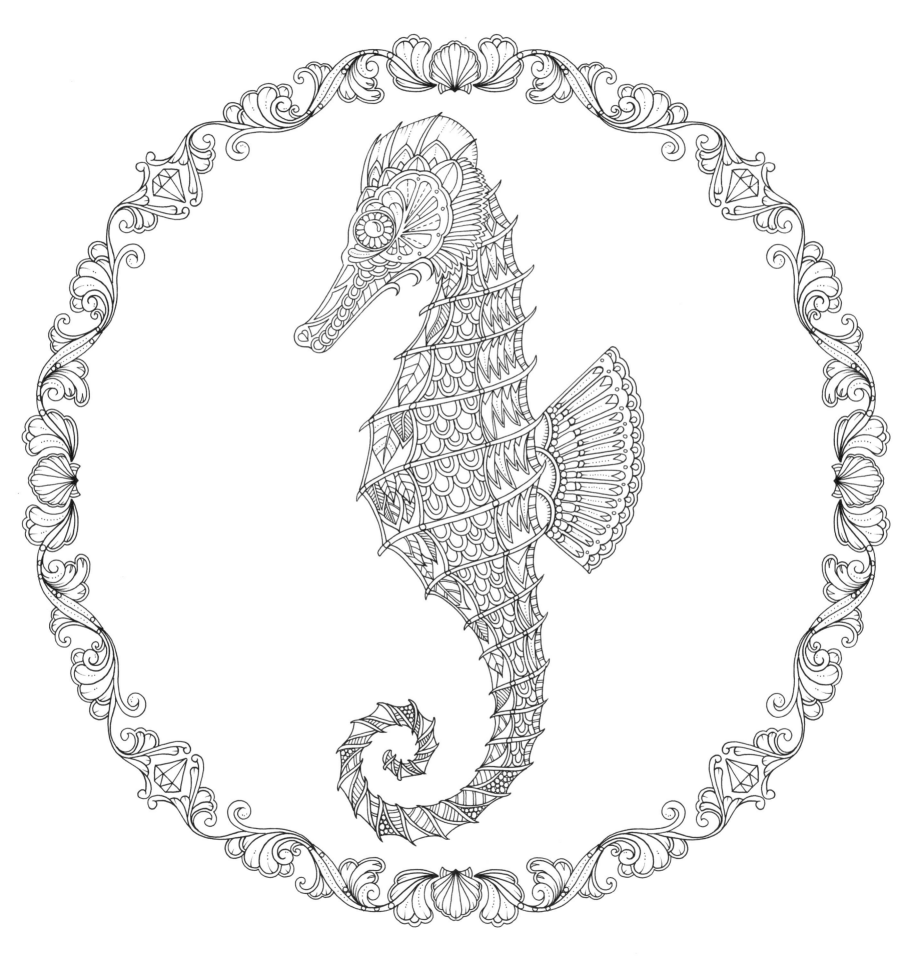

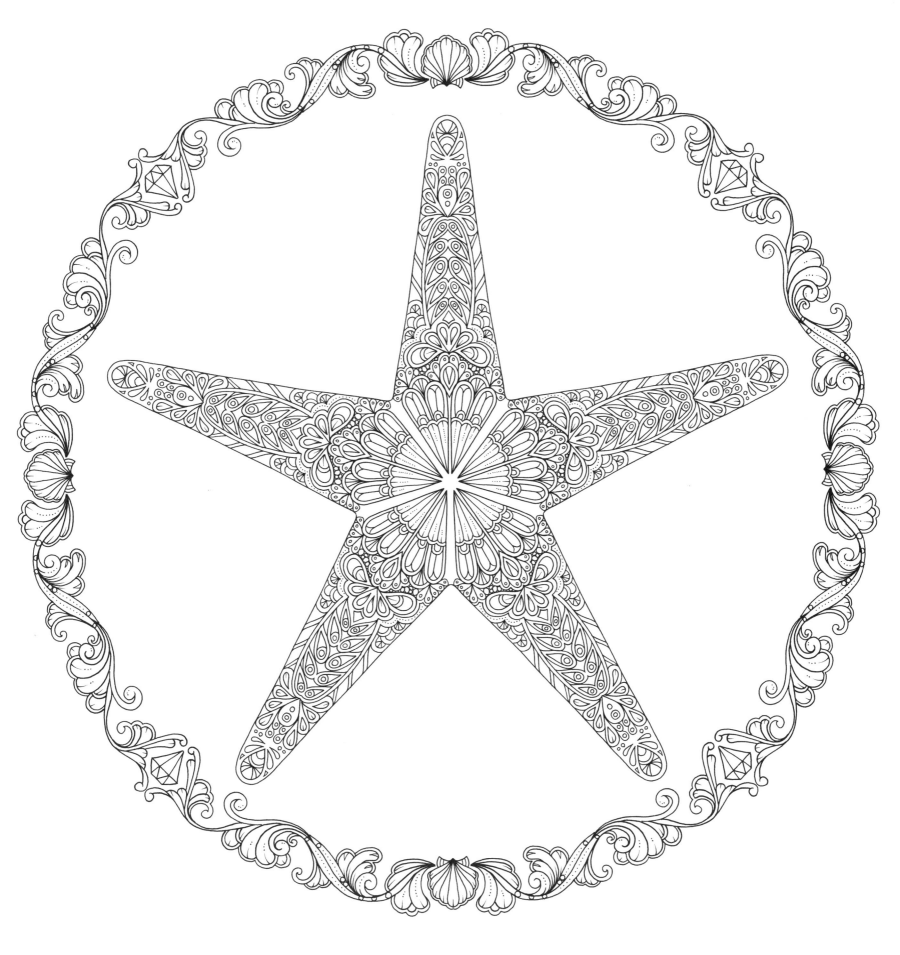

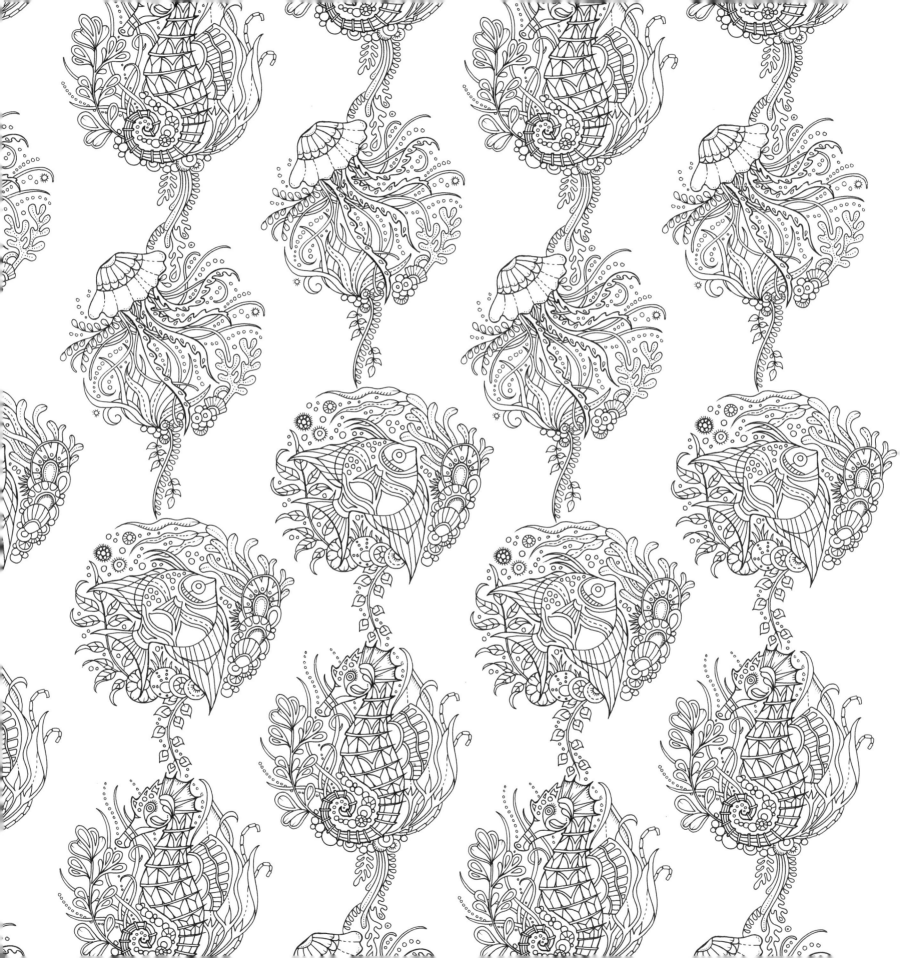

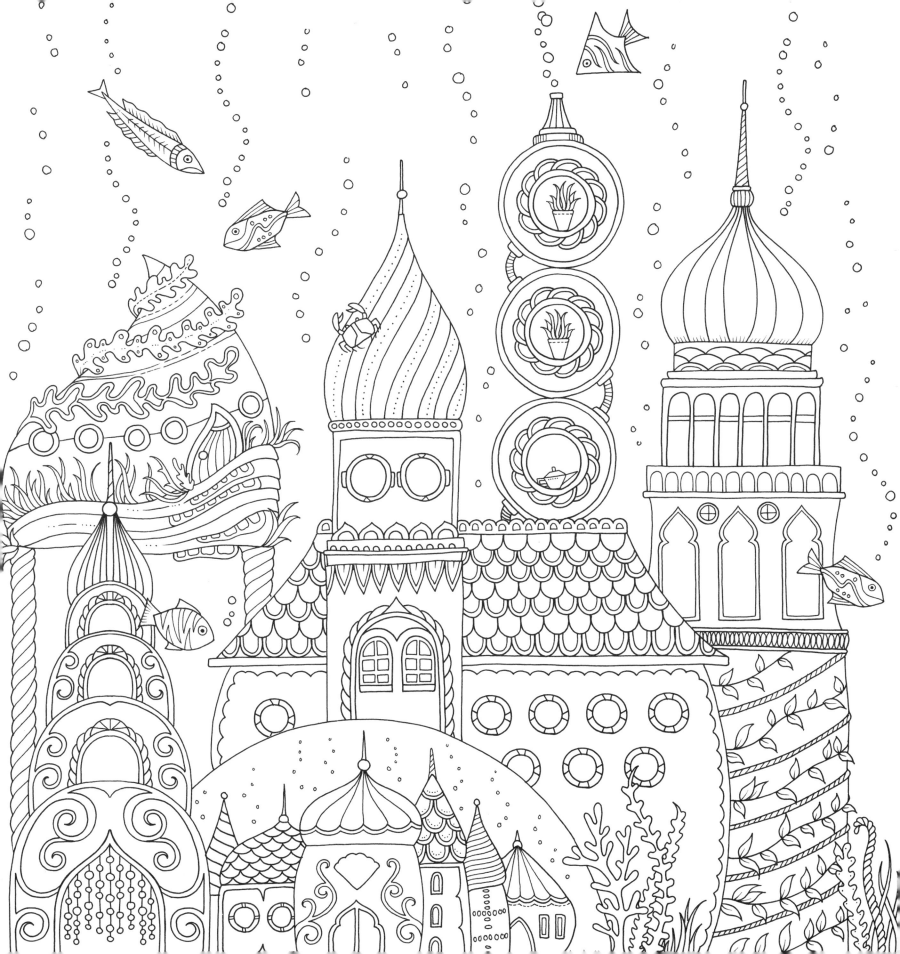

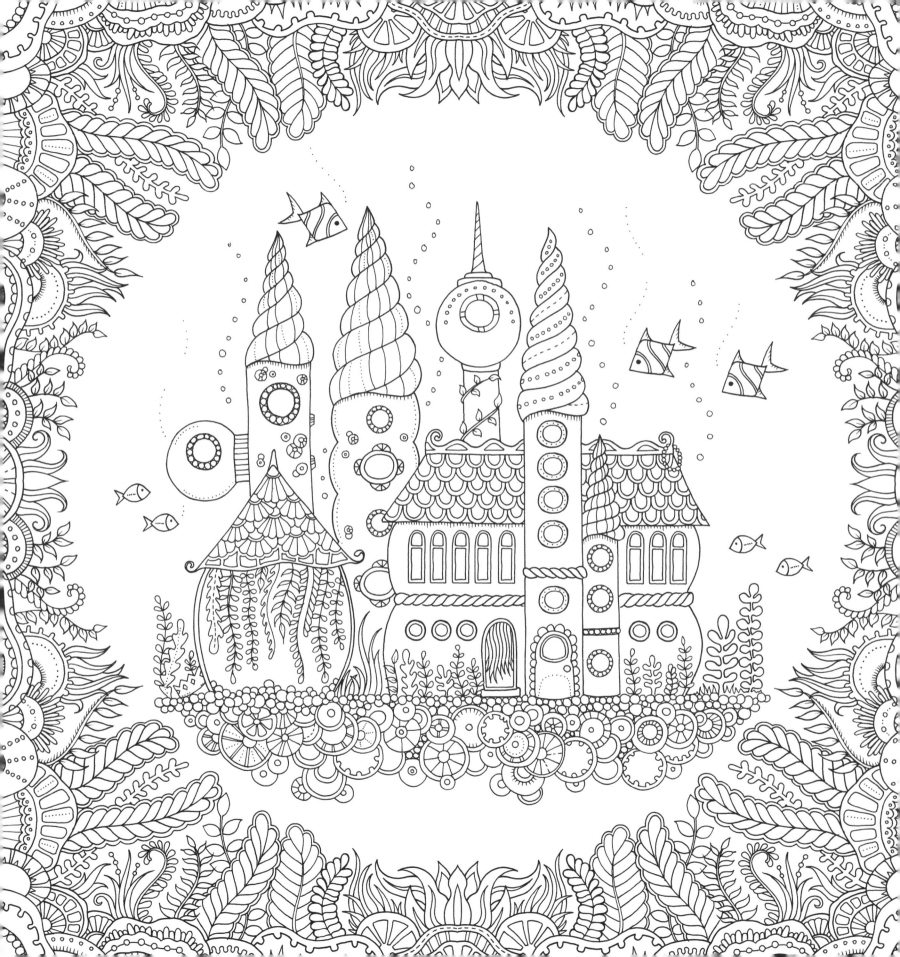

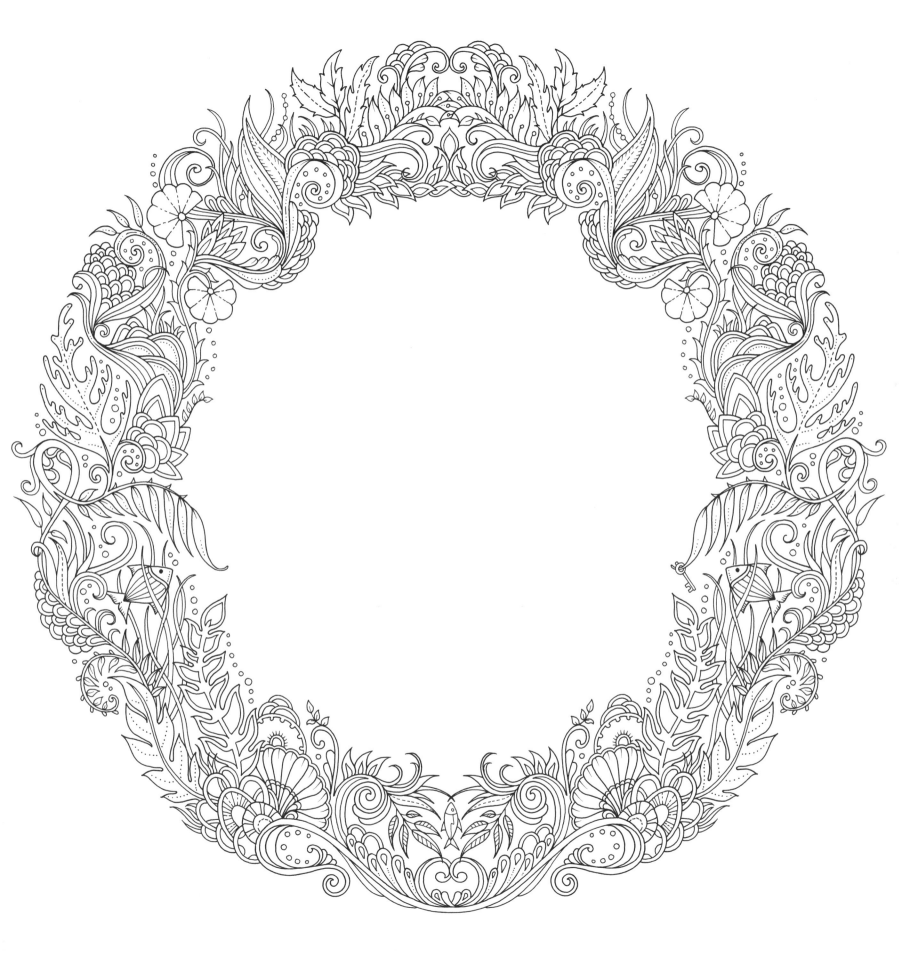

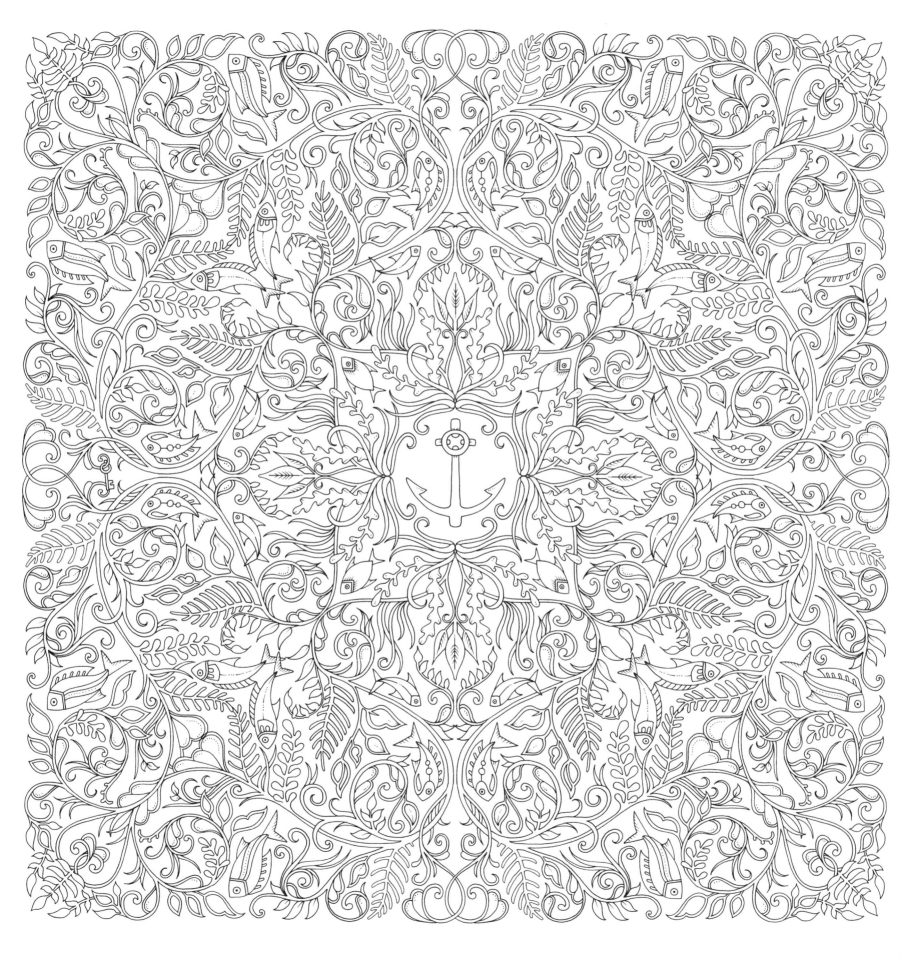

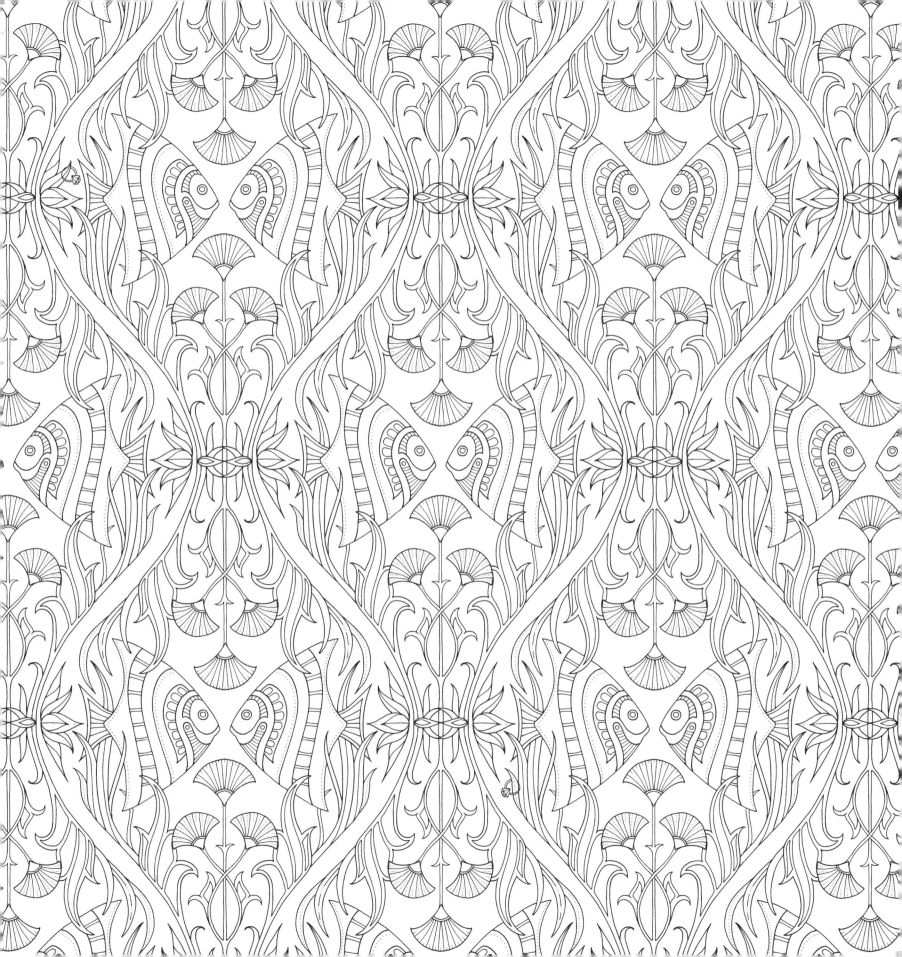

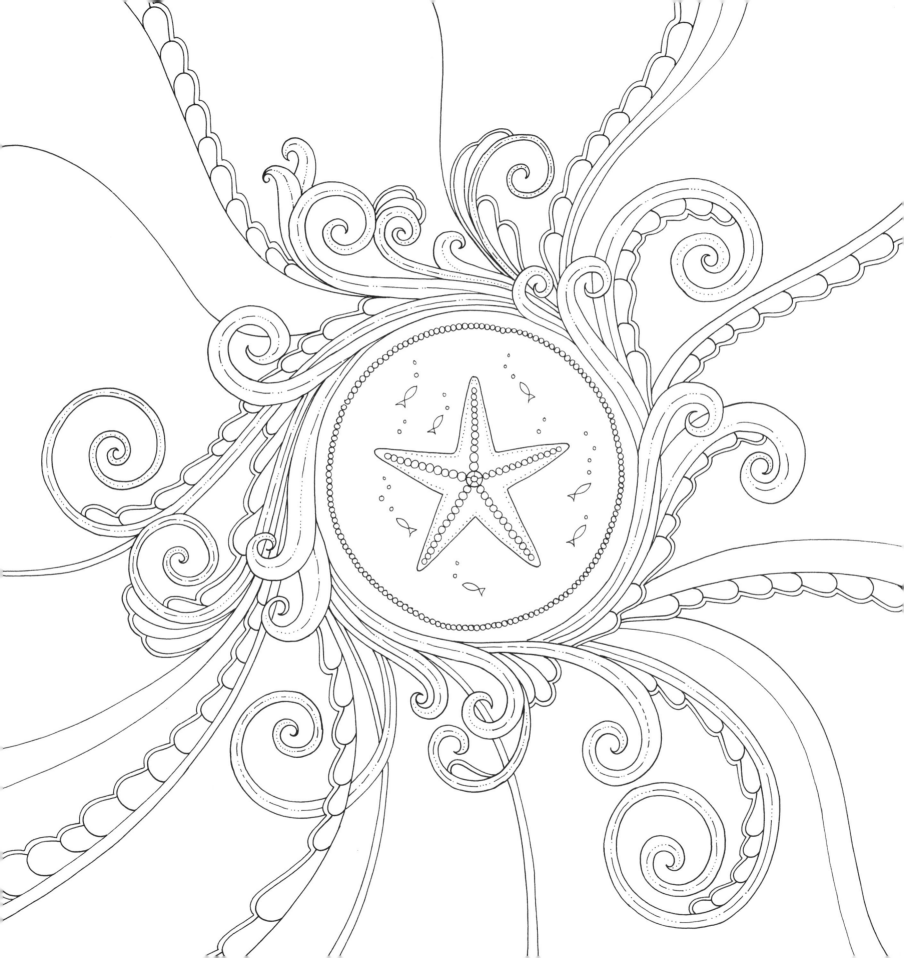

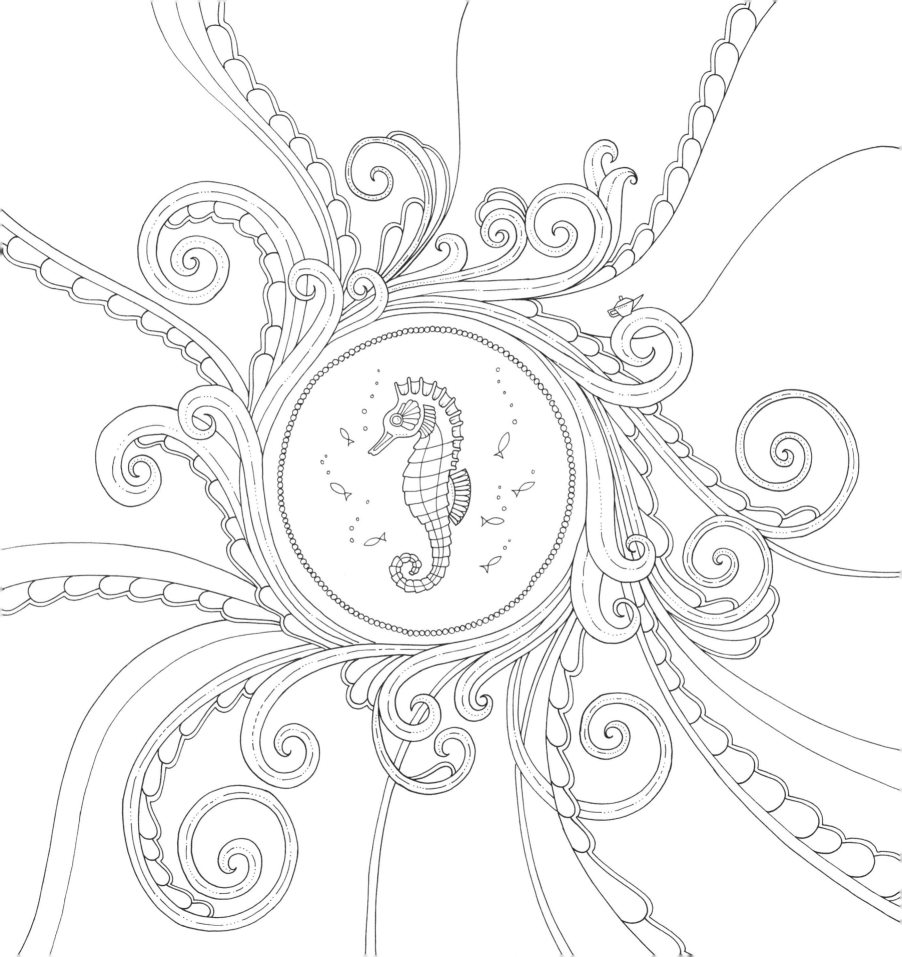

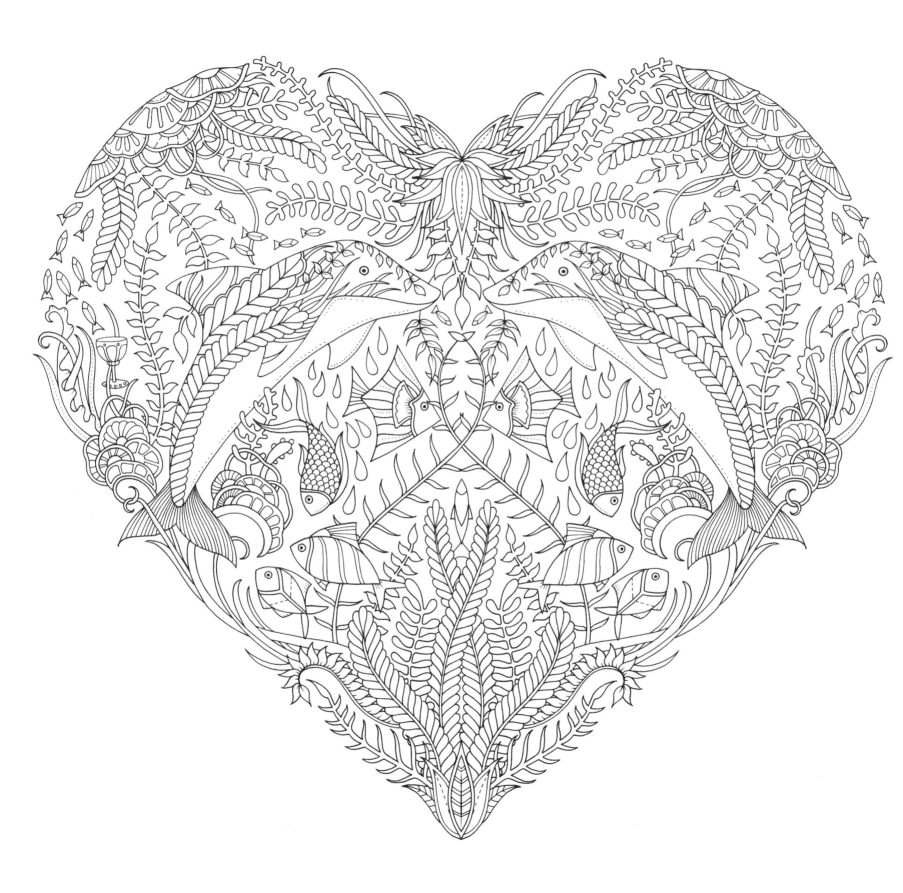

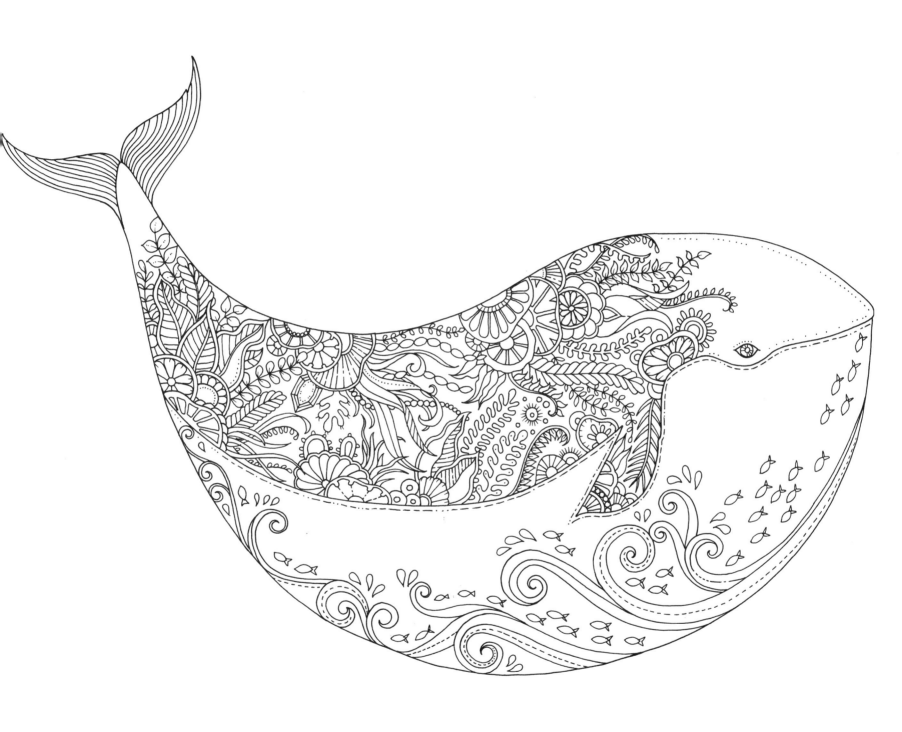

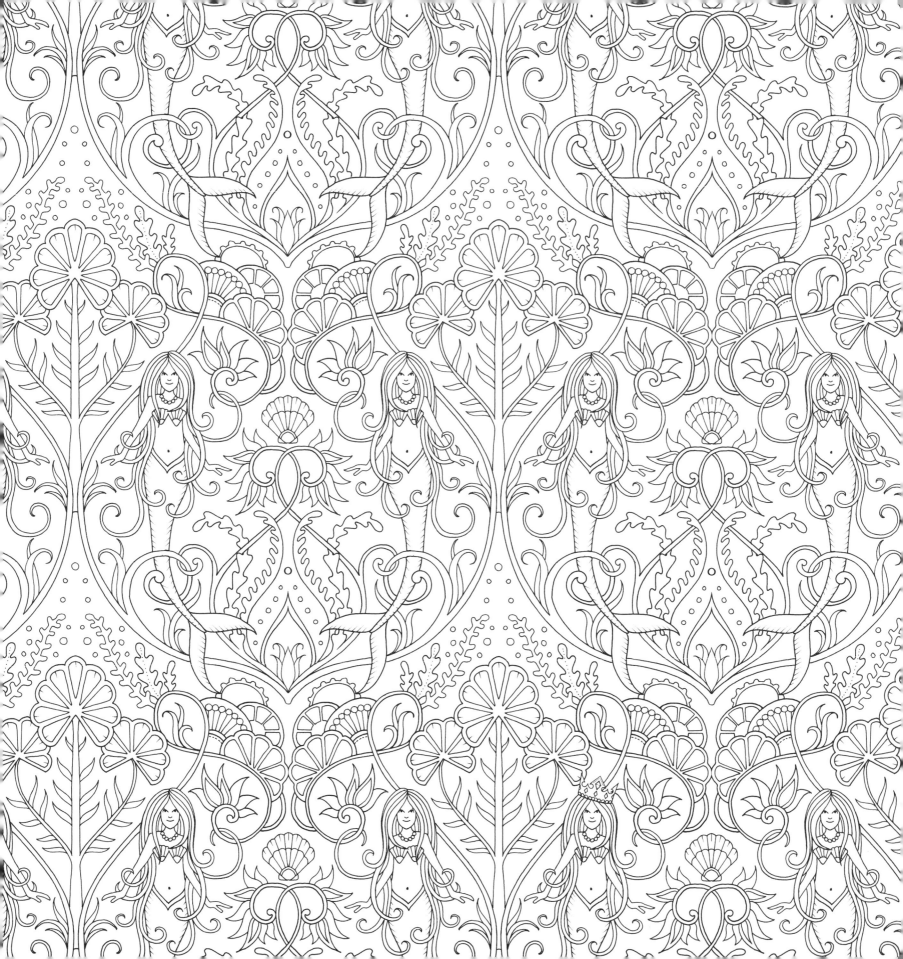

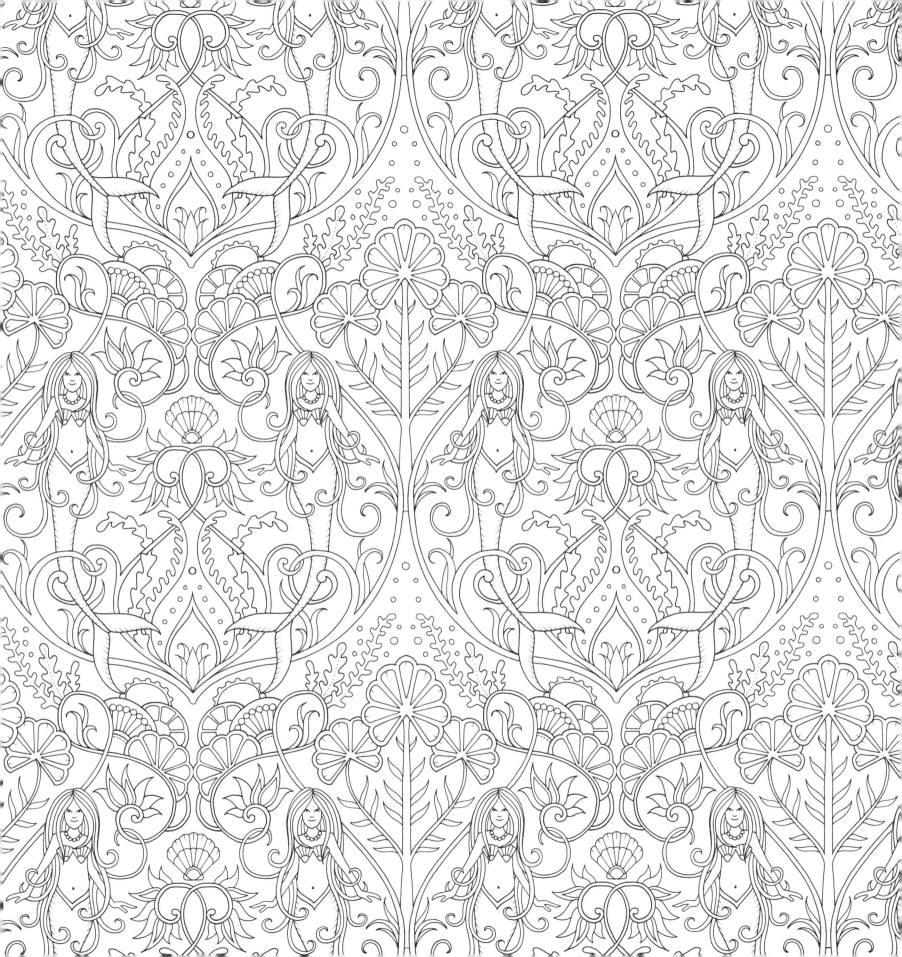

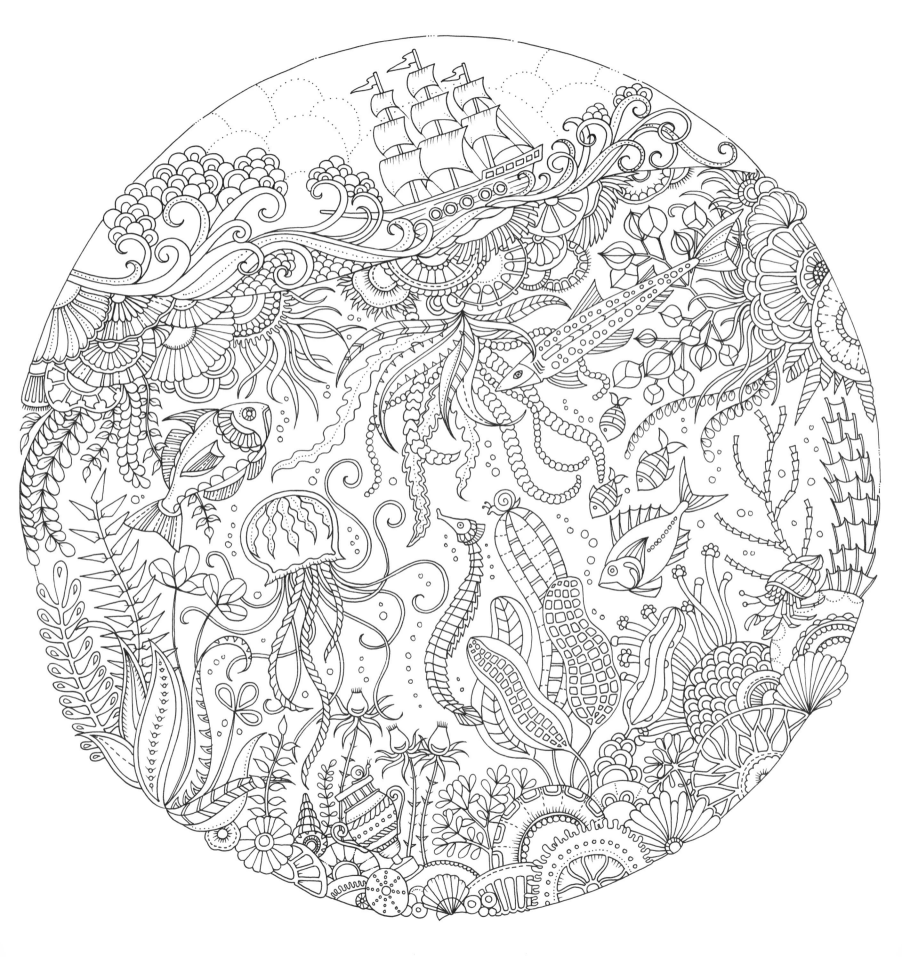

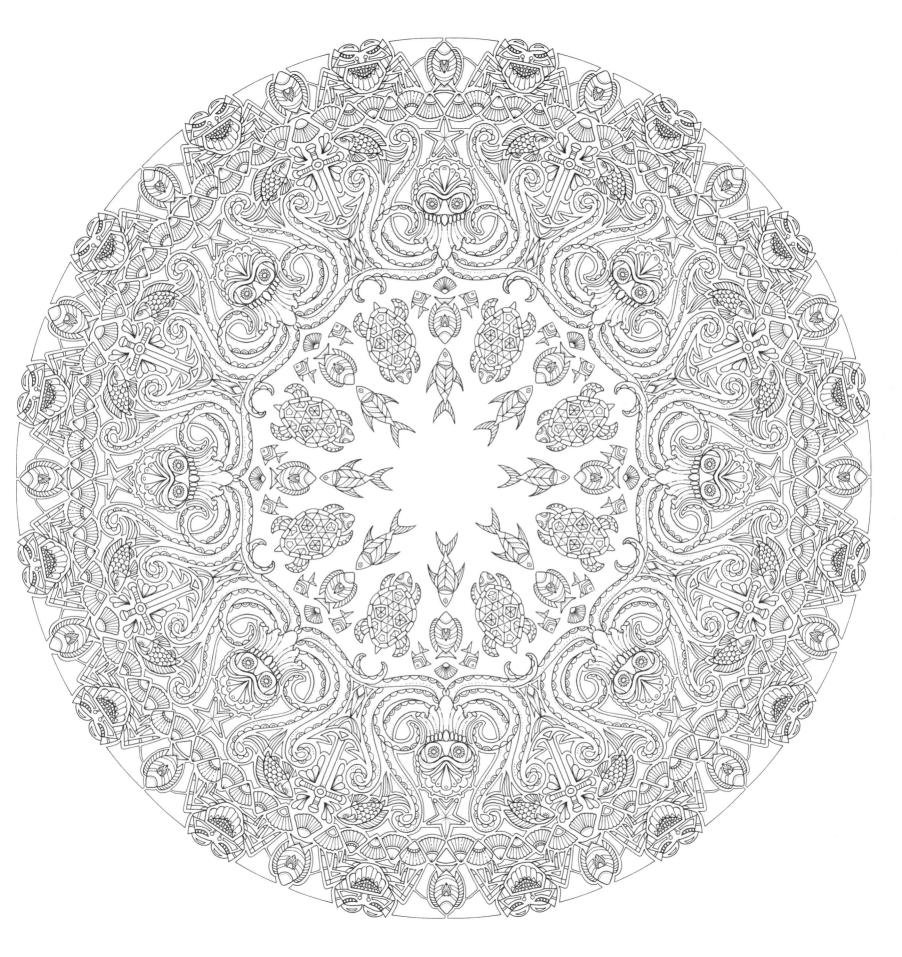

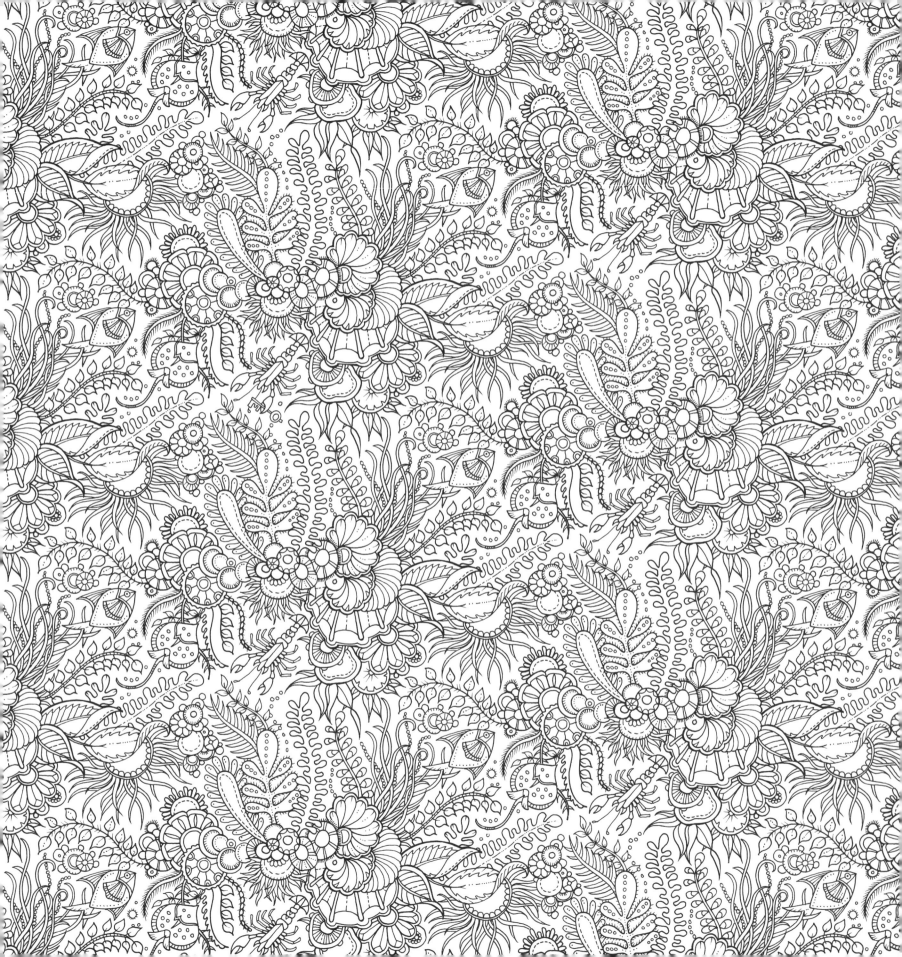

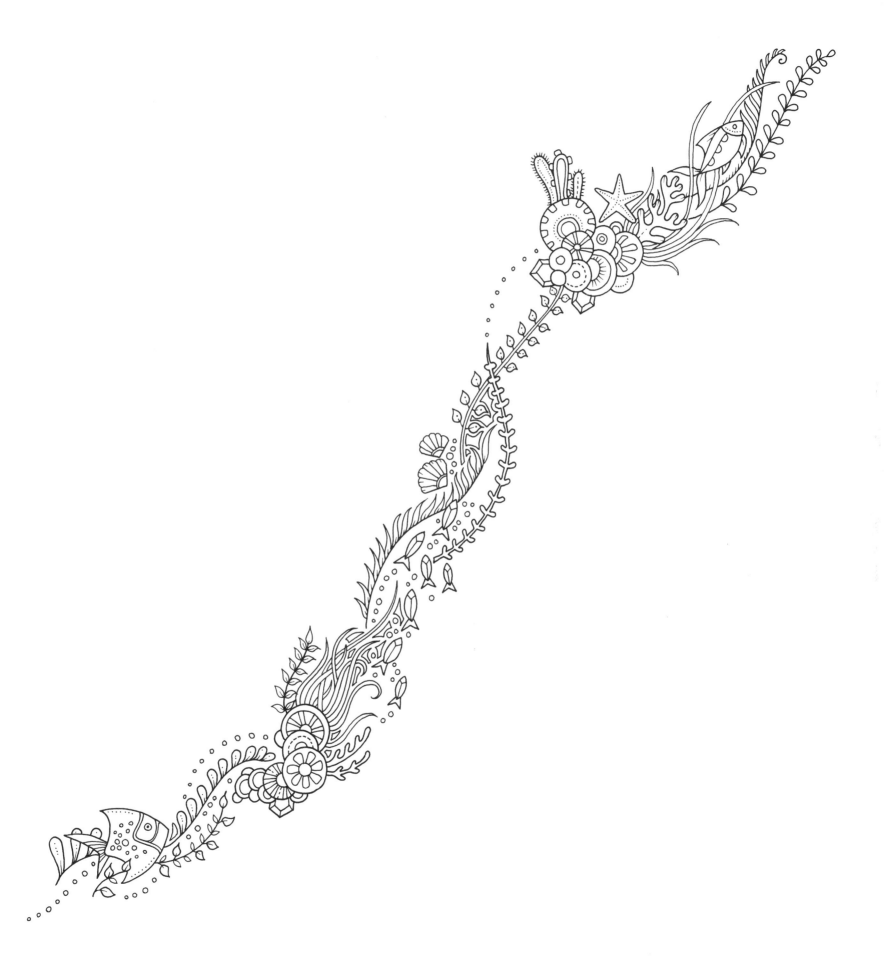

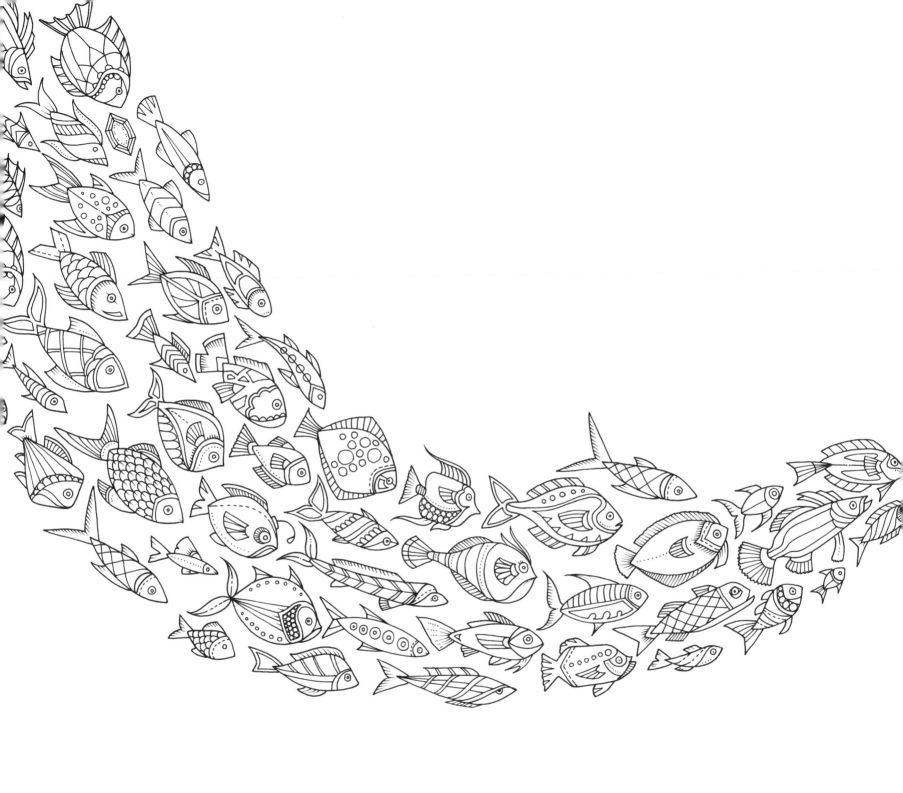

Key to the Lost Ocean . . .

迷幻海洋裡有……

1 goblet, 1 crown
1個高腳杯、1個皇冠

4 diamonds
4顆鑽石

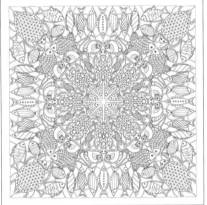

1 key
1把鑰匙

1 diamond
1顆鑽石

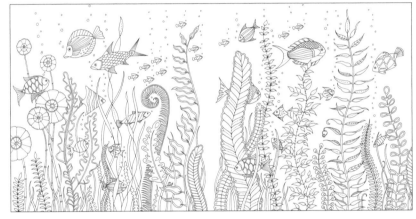

1 diamond ring
1個鑽戒

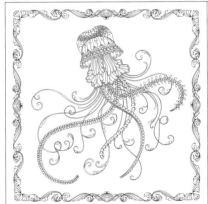

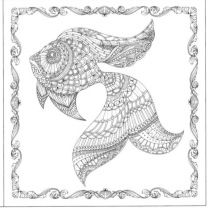

4 diamonds
4顆鑽石

4 diamonds
4顆鑽石

1 magic potion
1瓶魔法藥水

1 pocket watch
1個懷錶

1 diamond ring
1個鑽戒

1 key
1把鑰匙

1 diamond
1顆鑽石

1 diamond
1顆鑽石

1 vase
1個瓶子

1 dagger
1把匕首

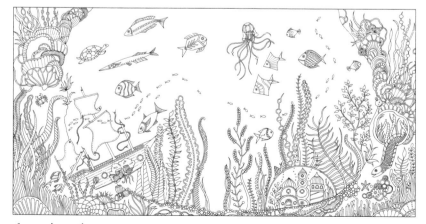

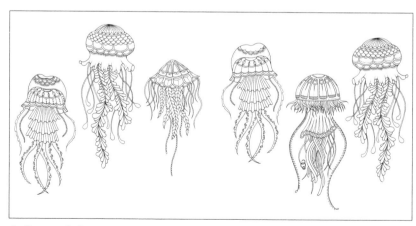

1 magic potion
1瓶魔法藥水

1 diamond ring
1個鑽戒

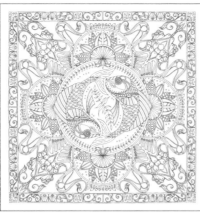

2 diamond rings
2個鑽戒

1 diamond ring
1個鑽戒

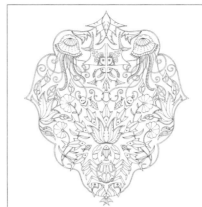

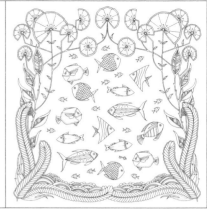

2 magic potions
2瓶魔法藥水

1 key
1把鑰匙

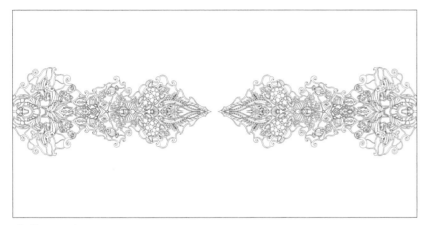

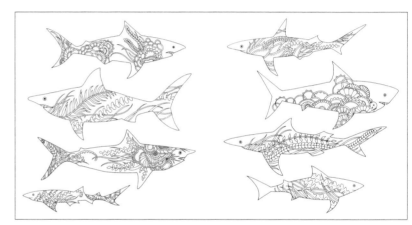

1 diamond
1顆鑽石

1 magic potion
1瓶魔法藥水

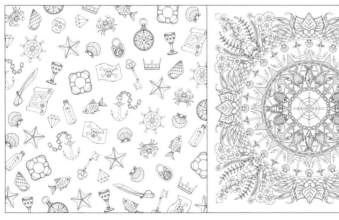

4 goblets, 4 diamonds, 3 keys,
3 crowns, 3 anchors, 3 messages
in bottles
4個高腳杯、4顆鑽石、3把鑰匙、3個
皇冠、3個錨、3個瓶中信

20 anchors, 8 diamonds
20個錨、8顆鑽石

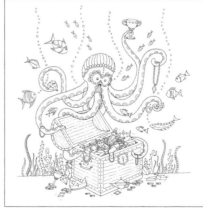

2 goblets, 2 crowns, 8 diamonds,
1 pocket watch, 1 magic lamp,
1 message in a bottle, 1 key, 6 pearl
necklaces, 7 gold bars, 39 gold coins

2個高腳杯、2個皇冠、8顆鑽石、1個懷
錶、1個神燈、1個瓶中信、1把鑰匙、6
條珍珠項鍊、7個金條、39個金幣

3 pearls
3顆珍珠

1 crown
1個皇冠

4 diamonds
4顆鑽石

4 diamonds
4顆鑽石

1 pocket watch
1個懷錶

1 diamond ring
1個鑽戒

1 diamond ring
1個鑽戒

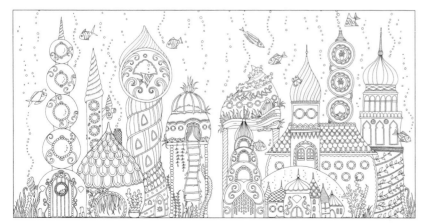

1 crown, 1 magic lamp
1個皇冠、1個神燈

1 crown, 1 pearl necklace
1個皇冠、1條珍珠項鍊

1 key
1把鑰匙

1 anchor, 1 key
1個錨、1把鑰匙

1 dagger, 1 anchor
1把匕首、1個錨

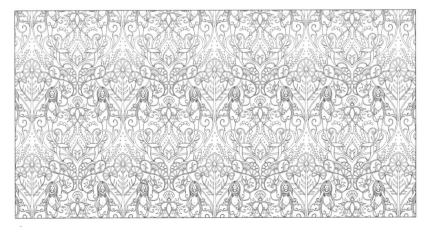

1 pocket watch
1個懷錶

1 diamond ring
1個鑽戒

2 diamond rings
2個鑽戒

1 magic lamp
1個神燈

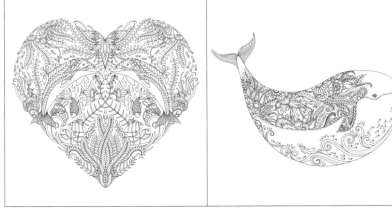

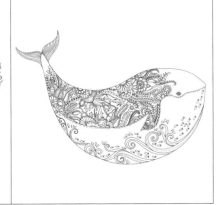

1 goblet
1個高腳杯

1 diamond
1顆鑽石

1 crown
1個皇冠

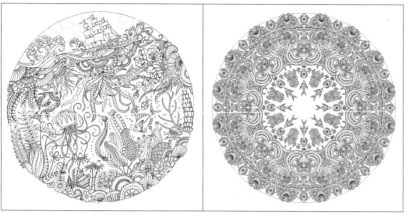

1 vase
1個瓶子

8 anchors
8個錨

1 key
1把鑰匙

3 diamonds
3顆鑽石

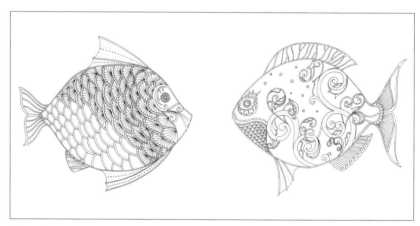

1 diamond
1顆鑽石

1 pocket watch
1個懷錶

1 dagger
1把匕首

1 anchor, 2 pearl necklaces
1個錨、2條珍珠項鍊